A TROUBLE-SHOOTING HANDBOOK

Watercolour
Problems and Solutions

With short, downward brushstrokes take care to leave white paper between tone

Paint small negative `shadow shapes´ between the groups of hairs

Important dark `shadow shape´

Take background colour in between groups of hair and enhance tone near base of stroke

Cool tone of background `pulled´ into hair at top of head to make it stand forward

Addition of Chinese white enhances highlights

Warm tone painted within ear shape, `cutting in´ to long hairs

Note how addition of pencil drawing over base tone and onto white paper suggests shadow

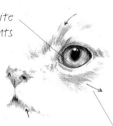

Arrows indicate direction of brushstrokes following hair growth

A TROUBLE-SHOOTING HANDBOOK

Watercolour
Problems and Solutions

Trudy Friend

David & Charles

To Mother

A DAVID & CHARLES BOOK

First published in the UK in 2002
by David & Charles
ISBN 0 7153 1306 1 (hardback)

Distributed in North America
by F&W Publications, Inc.
4700 E. Galbraith Rd.
Cincinnati, OH 45236
1-800-289-0963
ISBN 0 7153 1457 2 (paperback)

Printed in Hong Kong by Dai Nippon
for David & Charles
Brunel House Newton Abbot Devon

Editorial Director: Miranda Spicer
Commissioning Editor: Sarah Hoggett
Art Editor: Sue Cleave
Desk Editor: Jennifer Proverbs
Project Editor: Ian Kearey

This book is based on Trudy Friend's popular 'Problems and Solutions' series in
Leisure Painter magazine. For subscription details and other information, please contact:
The Artists Publishing Company Ltd, Caxton House, 63–5 High Street, Tenterden, Kent TN30 6BD,
tel: 01580 763315, fax: 01580 765411, website: www.leisurepainter.co.uk

Contents

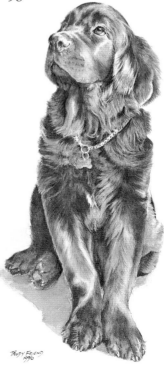

Introduction

With this book I will be helping you…
to love your art,
to live your art
and see the world go by
as colour, texture, line and form
and with an 'artist's eye'.

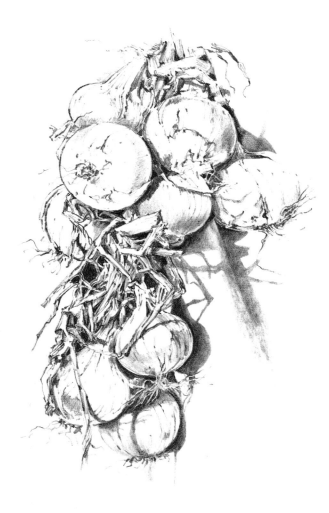

The aim of this book is to provide a learning experience that will help to guide you along an exciting path of self-discovery. If you have already embarked upon your own artistic journey, you may discover within these pages new ideas or variations to add to those you already use – enhancing and enriching your own ideas and methods. If you are a beginner or 'improver', this handbook is designed to show you the importance of understanding the basics and knowing how to use them as a firm foundation upon which to build your drawings and paintings.

Sketching and drawing

I believe that drawing is the most important basis for good paintings, and for this reason, each painting demonstration throughout the themed sections of this book is accompanied by a detailed drawing. Preliminary sketches enable you to look closely into your subject matter and familiarize yourself with all the intricate components before you embark upon any brushwork.

Try to think your way into all of your drawings and paintings – I call this 'putting your thoughts on paper'. For example, the 'wandering line' is an approach to drawing where the pencil is allowed to wander lightly over the paper surface, following the form of objects freely as you observe and depict the contours. Onions, with their many surface

veins, are ideal subjects for observing contour lines, as shown on pages 78–79.

There is also a diagrammatic approach, where you can put your thoughts on paper by using pencil guidelines and observing

the 'shapes between' in your preliminary drawings, as demonstrated on pages 14 and 66. By drawing in a linear way and accentuating the parts where you want to reinforce your knowledge prior to painting, you can develop a deeper understanding of the subject and produce a more convincing interpretation.

You can draw in a 'painterly' way; this is illustrated on page 72, where simple marks with a pencil, similar to brushmarks, are used to represent the background areas. And yet another way to put your thoughts on paper is to actually draw directional arrows on your sketches. In this way you are stating what you feel about what you see, and the arrows act as a reminder for brushstroke directions when you start to paint.

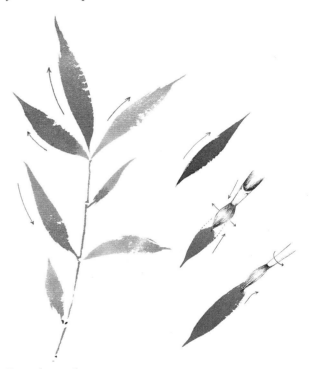

Brushstrokes

You should try to become involved with your subject and media in order to gain as much knowledge of them as possible. The best way is to start with brushstroke exercises, and for this reason each theme in the book commences with a 'Brushstrokes' spread – on one page you can see the basic strokes, and on the facing page how each of these can be used within the specific theme. Practising in this way will also help you to discover which papers and brushes suit your own personal style.

Brushstroke exercises are the basis for the

learning process, and by practising them you will be able to develop your own style of working. From these basic strokes you will discover many more of your own to incorporate within your watercolour paintings.

Once again, the importance of drawing comes to the fore here – even the simple brushstroke exercises on pages 20–23 require some basic knowledge of shape and form that is best obtained initially through close observation and drawing exercises.

You do not need to be 'tight' in your general approach to painting, but I do believe that discipline leads to freedom – should you choose to eventually paint with freely applied brushstrokes in a loose style, you can experience nothing but benefit from going back to basics in your approach every now and then.

Learning from your mistakes

As with so many aspects of watercolour painting, it is practice that can help you steadily improve – providing, of course, that you learn from your mistakes. It is by trial and error that we learn our most lasting lessons, and only by facing problems head-on can we resolve them.

Mishaps do occur from time to time, and even when you feel you have mastered a particular technique things will occasionally go wrong. Alternatively, sometimes there can be 'happy accidents', when an unintentional effect actually enhances the painting – though it is not a good idea to expect these to happen.

I feel it is unwise to discard any paintings with mistakes – even when things do go disastrously wrong – until we have learned all we can from them and repaired them wherever possible, as shown on pages 34–39. This may involve a simple solution like redrawing, using another medium over the watercolour, or cutting out and mounting the idea that has been successful. Slight corrections can be made by scraping away the offending marks with the point of a sharp craft knife. Should a large part of the picture prove to be

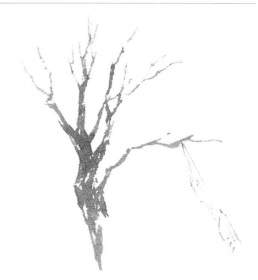

disappointing, you can redraw and paint gouache over the entire painting. Using plenty of water with the pigments is one way of removing mistakes quickly, as described below.

Choosing and stretching paper

It is worth experimenting with papers of different weights and surface textures, which are examined in the first section of this book. Personally I prefer to work on paper that has been stretched beforehand – except when using a heavyweight paper. You may not wish to stretch a 300gsm (140lb) paper, but it is advisable to stretch anything below that weight.

To stretch paper you need a roll of gummed paper, scissors, a solid board that is slightly larger than the sheet of paper, a large container of water (a bath is ideal), a clean sponge and a clean paper kitchen towel. To start, cut the gummed paper into four strips to correspond with, and be slightly longer than, the sides of the paper, and leave them where they are easily to hand.

Wet the paper thoroughly – immersing it in water is best – and allow the excess moisture to drip off it before placing it on the board, with a margin of board showing around the edges, and gently smoothing it flat with the sponge. Moisten the gummed strips and apply them with half the width on the paper and half on

the board. Smooth out any air bubbles and blot gently with the paper kitchen towel.

Allow to dry flat at room temperature before using – if you tilt the board while the paper is drying, the excess moisture may accumulate along the lower edge, causing the gummed strip to lose adhesion and lift away when dry. Should the paper buckle or 'cockle' when drying, it may still dry flat eventually. If it is undulating when completely dry, simply remove it and repeat the process; you will soon learn with practice.

Working with water

It is wise to remember that watercolour painting means using plenty of water, and that when learning new techniques it is far safer to err on the side of too much water than too little. Without fluidity of your medium, the fluidity of your thoughts and ideas being interpreted in an exciting way is hampered.

To give you confidence in using a lot of water with pigments, mix a green or neutral brown in your palette to produce a rich hue, then add more water than you think may be necessary while still retaining the pigmentation. Paint a simple shape using freely applied strokes, then immediately blot off with a paper kitchen towel until the paper is dry. If you have used enough water, you will see that only a pale stain remains on the paper, which means that if an image painted in this way does not appear as anticipated, you can remove almost all traces of it by blotting off immediately.

Becoming involved with your work

We all learn from each other and from our surroundings each day of our lives – for learning is a continuous and expanding process. Be aware of everything and keep your 'artist's eye' open to all possibilities. The best artwork comes from the commitment and involvement of the artist. The more you give of yourself to the creation of your work, the more successful you will feel it to be.

Try to avoid a superficial approach, and be sincere in what you are trying to express with your pencil and brush. Self-knowledge will develop if you remember the three P's – Practice, Patience and Perseverance.

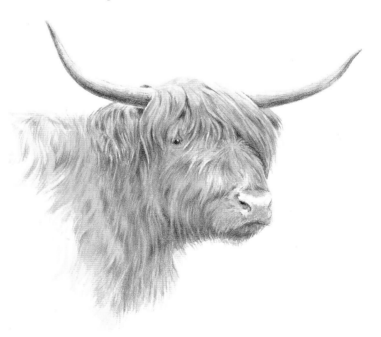

Materials and Techniques

Whether drawing or painting, it is important that you understand how to use your materials to best effect, which ones work together and which suit your style and capabilities – it may also be that some of the problems you have experienced have arisen because you have combined pencil or brush with an unsuitable paper. Choose the best materials you can afford, treat them with care, and practise using them in exercises that help you develop your skills.

Choosing pencils

Graphite pencils for drawing can be from the hard H range to F or, if a softer effect is required, from HB to the very soft 9B. As underdrawings for watercolours HB to 2B work well, because they are not too hard (because this might cause indentations) or too soft (because the marks might smear when water is applied).

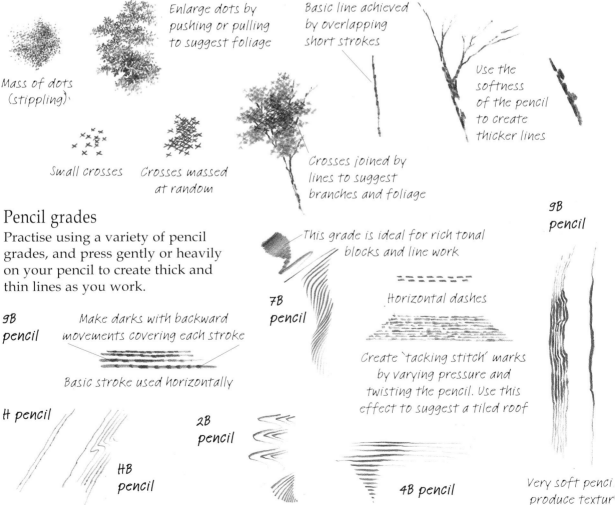

Enlarge dots by pushing or pulling to suggest foliage

Basic line achieved by overlapping short strokes

Mass of dots (stippling)

Use the softness of the pencil to create thicker lines

Small crosses Crosses massed at random

Crosses joined by lines to suggest branches and foliage

9B pencil

Pencil grades

Practise using a variety of pencil grades, and press gently or heavily on your pencil to create thick and thin lines as you work.

This grade is ideal for rich tonal blocks and line work

7B pencil

Horizontal dashes

9B pencil

Make darks with backward movements covering each stroke

Basic stroke used horizontally

Create 'tacking stitch' marks by varying pressure and twisting the pencil. Use this effect to suggest a tiled roof

H pencil

HB pencil

2B pencil

4B pencil

Very soft penci[l] produce textur[e] in lines

Fine lines create less intensity Softer pencils create both fine lines and rich darks

Brushes and their marks

Although many brush movements are the same as pencil movements, the element of water mixed with pigment allows shapes to merge and blend. A larger surface area can also be used with a brush – from the tip 'on your toes' position (see p. 20) through to the full extent of the hairs laid horizontally (see p. 23). It is this variety, and the many angles and pressures that can be applied, that adds excitement to brushwork.

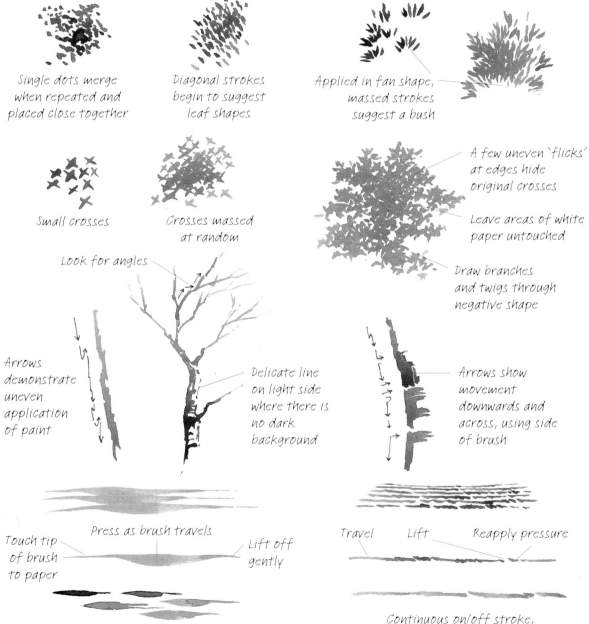

Single dots merge when repeated and placed close together

Diagonal strokes begin to suggest leaf shapes

Applied in fan shape, massed strokes suggest a bush

Small crosses

Crosses massed at random

A few uneven `flicks' at edges hide original crosses

Leave areas of white paper untouched

Draw branches and twigs through negative shape

Look for angles

Arrows demonstrate uneven application of paint

Delicate line on light side where there is no dark background

Arrows show movement downwards and across, using side of brush

Touch tip of brush to paper

Press as brush travels

Lift off gently

Travel Lift Reapply pressure

Use strokes to suggest ripples on water, similar to `one-stroke' leaf shapes

Continuous on/off stroke, useful for tiled roof areas

Observation

Learning to look at your surroundings with an 'artist's eye' requires a special kind of observation. Try to look for different aspects of everyday objects and, as well as observing the positive forms in a group, also note the negative shapes between and around them.

Personal grid

To understand and use this method, place a tracing paper overlay over a still-life photograph. Look closely at the photograph, observing the points where one object touches or crosses another – the contact points. It is from these points that your grid lines may be drawn. Use only vertical and horizontal lines, as these are easy to check for accuracy with a set square.

From a point where one object comes into contact with another, draw horizontal and vertical lines on the tracing paper. Look along the these lines, and note where other parts of your subject(s) fall along them. In this case, at (a) the lines meet an angled area of stem, so you need to make sure that this point aligns with (b) – the initial contact point where the yellow pepper touches the shadow of the red one.

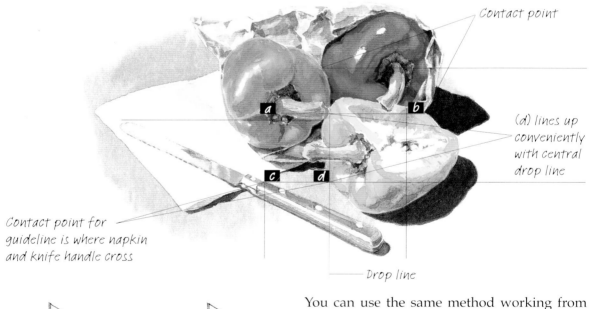

Contact point

(d) lines up conveniently with central drop line

Contact point for guideline is where napkin and knife handle cross

Drop line

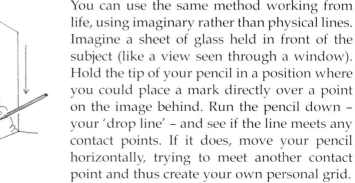

You can use the same method working from life, using imaginary rather than physical lines. Imagine a sheet of glass held in front of the subject (like a view seen through a window). Hold the tip of your pencil in a position where you could place a mark directly over a point on the image behind. Run the pencil down – your 'drop line' – and see if the line meets any contact points. If it does, move your pencil horizontally, trying to meet another contact point and thus create your own personal grid.

Negative Shapes

Negative shapes are the shapes between the actual objects. They enable you to place your objects correctly in relation to each other when used in conjunction with your personal grid. As an exercise, draw some simple negative shapes as shapes only, not necessarily in context. With a pencil, tone within the outline you have drawn and create a solid block. Compare your shape with the one you see between the objects in front of you.

Choosing a starting negative shape

The group of three bell peppers and a knife below shows examples of small, medium and larger negative shapes. Practise starting a study of still life by drawing what you regard as the most important or relevant negative shape – the shape that, when it is drawn, will help you place the most objects accurately, in relation to each other. In the illustration here, this would be the medium shape, as it will lead naturally, with the use of guidelines, to being able to complete all three peppers.

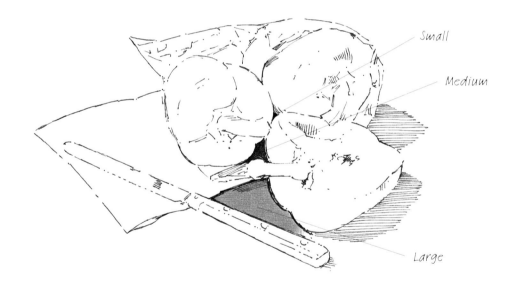

Small

Medium

Large

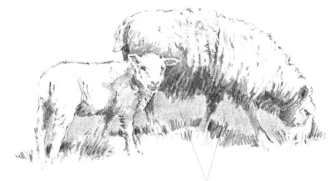

Negative shapes

Larger negative shapes

The negative shapes between the sheep and lamb's legs are quite simple and easy to draw, and help you fix the proportions of the animals accurately.

Guidelines

Once you have established your personal grid of vertical and horizontal guidelines, and allied this to negative shapes, you will have a scaffolding upon which you can build your drawing. You now need to look for further 'shapes between' to help accurate placement.

Finding guidelines

The areas coloured in green show how to use a guideline to complete a 'shape between'. In this way you are creating more shapes to relate to each other and thus gain greater accuracy.

It is like a jigsaw puzzle, where the pieces fit together – or a spider's web. To avoid getting lost with an intricate grid, include solid tonal negative shapes and shadow shapes.

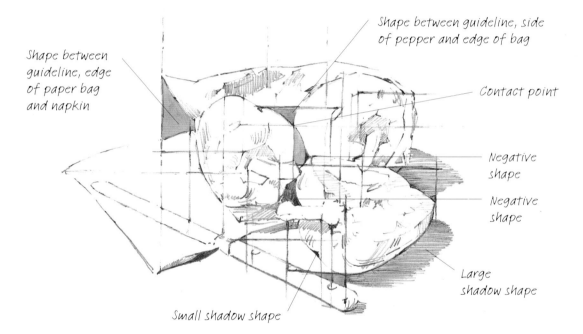

Shape between guideline, side of pepper and edge of bag

Shape between guideline, edge of paper bag and napkin

Contact point

Negative shape

Negative shape

Large shadow shape

Small shadow shape

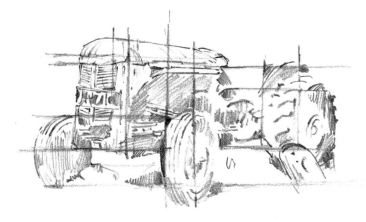

Composing with guidelines

This rough sketch of a tractor (refer to p. 102 for the final drawing) shows how you can use guidelines to plot out your composition from the start.

Tone

Before you start watercolour painting, think of your subject in black and white – a black-and-white photo will help you understand the range of tones.

Toning for tone or toning for colour

Improving your awareness of tonal contrasts can help you establish tonal blocks (masses of light against dark and vice versa) that create the design of your pictorial composition. You can practise tonal blocks with pencil (as below) or one neutral watercolour. This tonal study of three bell peppers and a knife demonstrates how some tones suggest colour (toning for colour), while others relate to shadow areas (toning for tone).

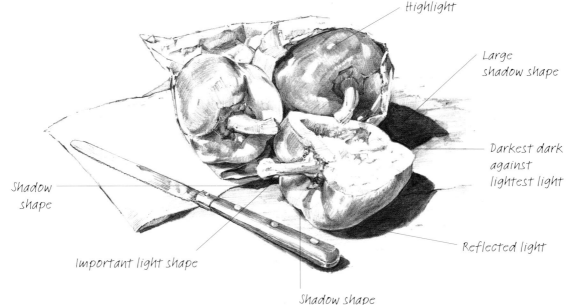

Highlight

Large shadow shape

Darkest dark against lightest light

Reflected light

Shadow shape

Important light shape

Shadow shape

Tonal blocks

Whether toning for tone or toning for colour, it is the variety of tones and contrasts that bring excitement to your pencil work. Make a series of eight tones to which to refer as your work progresses. Keep reminding yourself to look for the tonal contrasts within your subjects, and use as many different ones as possible.

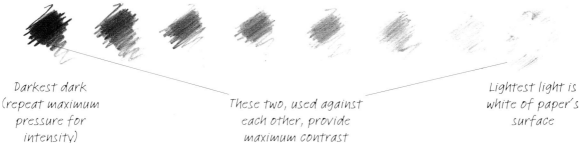

Darkest dark (repeat maximum pressure for intensity)

These two, used against each other, provide maximum contrast

Lightest light is white of paper's surface

Drawing within Shadows

Strong sunlight, with its resulting cast shadows, gives you an opportunity to use contrasts of light against dark. If you look closely within shadow areas you can see a further variety of tones, more closely related but at the same time still very clear.

Ways of adding shadows

Old buildings present a wealth of interest, and strong sunlight brings out exciting tonal contrasts. Using a smooth-surfaced white drawing paper, tone in an area to represent cast shadow and then draw within it, either in a linear way or with more tonal blocks. Alternatively, you can draw the objects prior to adding a tone that suggests a cast shadow over your drawing. This kind of drawing requires good pencil control.

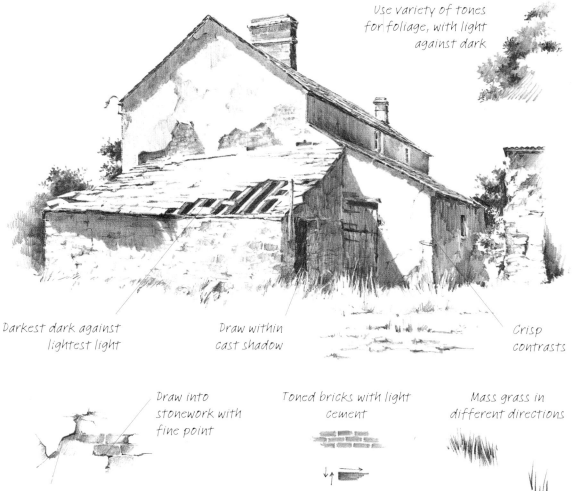

Use variety of tones for foliage, with light against dark

Darkest dark against lightest light

Draw within cast shadow

Crisp contrasts

Draw into stonework with fine point

Start with crisp line and then tone away to represent shadow behind plaster

Toned bricks with light cement

Start the stroke with vertical movement then horizontal strokes

Mass grass in different directions

Use a variety of strokes

Tonal watercolour exercise

Observe details within a shadowed area – pebbles on a beach within the shadow of a rock, for example – and paint them using one colour, then mix a neutral shadow tone and sweep the shadow shape over the pebbles. If you have used translucent washes for the pebbles and allowed the paint to dry thoroughly, you will see the image clearly through the shadow area. Do not mix too much pigment in your shadow colour.

Following form within shadow shapes

Study shadows closely, especially the way in which cast shadows curve and disappear behind light forms that cut across. This will help you understand how to create a three-dimensional impression of the subject. A simple example is when a cast shadow over grass causes dark shapes to cut into light (behind) and light into dark (foreground).

Leave white paper untouched where full sunlight touches surface

Negative shapes within handles

Darkest dark against lightest light

There can be many tones within a shadow area

Tiny negative shadow shapes

Practising with tone

To render tone effectively in many situations you need to learn pencil control – use as many completely different subjects as you can to build this up.

Use heavy pencil pressure to create shadow line over area of tone

Tone in same direction as first block to create shadow shape on top

Tone in Watercolour

These pages demonstrate the need for varied pressure and angles of the brush to make different movements. To achieve a diversity of tones you can either use a variety of diluted washes, building one upon the other, or blending the washes together.

Diluting paint

Lift a good reservoir of water into your palette – more than you might normally use – using a large brush. Wet a smaller brush and lift some pigment from the pan, adding it to the water until you have a pale tint. Brush this onto watercolour paper. Add more pigment and try the resulting mix again. Continue to do this until you have a range of tones. Even your darkest tones should be fluid.

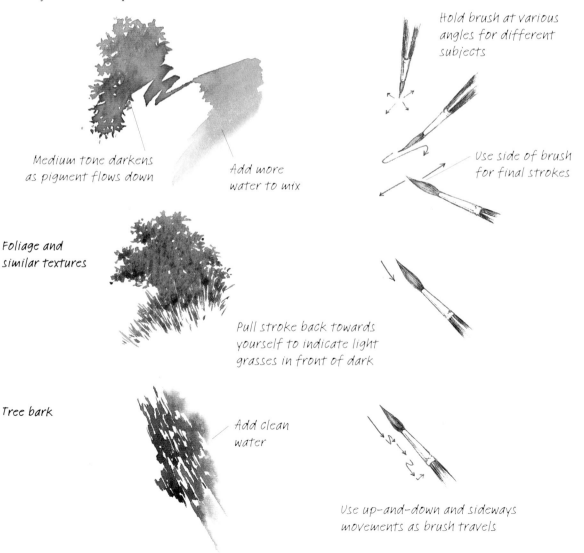

Medium tone darkens as pigment flows down

Add more water to mix

Hold brush at various angles for different subjects

Use side of brush for final strokes

Foliage and similar textures

Pull stroke back towards yourself to indicate light grasses in front of dark

Tree bark

Add clean water

Use up-and-down and sideways movements as brush travels

Blending to make curves

Not all tree bark has a rough texture, and the smoother surfaces of some tree trunks offer opportunities to blend from the dark side of the bark into the light.

Alternative tree bark

—— *Clean water for blending*

↓

Hold brush horizontally with full length of hairs on paper

→

Follow downward movement with sideways pull. Lift completely from paper at uneven intervals to add texture and highlights

Repetitive images

This exercise helps to develop the ability to work at speed when reproducing images like those of bricks, stones, blocks and other flat areas with repeated patterns or textures.

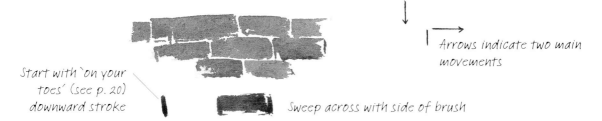

Start with `on your toes' (see p. 20) downward stroke

Sweep across with side of brush

Arrows indicate two main movements

Moving images

These images are best achieved by swiftly applied strokes, so be prepared to practise painting at speed to achieve spontaneity.

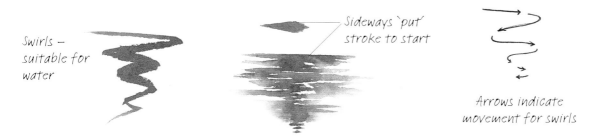

Swirls – suitable for water

Sideways `put' stroke to start

Arrows indicate movement for swirls

19

Getting to Know Your Brushes

These one-stroke brush exercises are designed to help you develop confidence. If you practise them regularly you will soon find that you have more control over your brush and are able to vary the speed at which you work and the thickness of your strokes.

Directional strokes
One-stroke leaf shapes may be executed both upwards from the stem stroke, or starting away from the stem and travelling towards a twiddle.

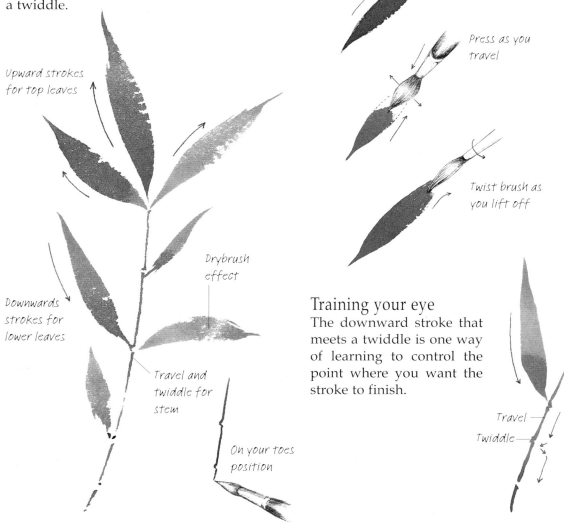

Brush positions

'On your toes' position with brush almost vertical

Angle brush for twist and lift off

Touch tip of brush to paper

Press as you travel

Twist brush as you lift off

Upward strokes for top leaves

Drybrush effect

Downwards strokes for lower leaves

Travel and twiddle for stem

On your toes position

Training your eye
The downward stroke that meets a twiddle is one way of learning to control the point where you want the stroke to finish.

Travel

Twiddle

Combining long and short strokes

This exercise is an extension of the one shown opposite and demonstrates how to place short strokes alongside sweeping, extended shapes. The slender stem and 'tails' on the ears encourage concentration and control.

Basic 'put' stroke

This stroke places the whole length of the brush once upon the paper, lifting off immediately. It can be extended by placing and pulling downwards a little before lifting off.

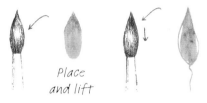

Place and lift

Longer shape. Pull down a little as you lift off

Directional 'put' strokes

A series of 'put' strokes in formation can be executed by placing the stroke at one angle, lifting off, turning the brush to a different angle and placing another stroke, and so on.

Consider direction of strokes

Full brush pressure

Draw joining line with tip of brush

Make smaller shape with tip only

Joining 'put' strokes

The series of 'put' strokes can then be joined by a curved or angled (stem) line to represent a recognizable image.

Draw brush line away from shape for highlight

Train your eye

A downward stroke that meets the tip of an image is one way of learning how to control the brush point at which you want the stroke to finish

Complete image

After having practised the exercises on these pages, you should be in a position to combine them and produce a complete image in the form of an ear of corn with a stem and long, tapering leaves.

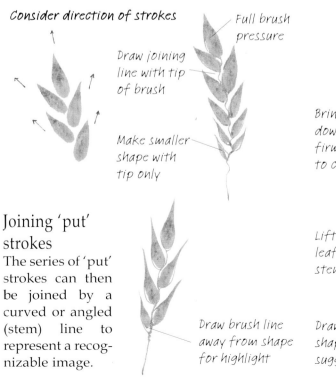

Fine, delicate shadow lines

Start leaf stroke away from stem

1 Apply single upward stroke swiftly
2 Stop the stroke and lift brush before finishing stroke
3 Add finely drawn line to suggest edge of curve

Bring stroke down, adding firm pressure to create width

Lift pressure as leaf approaches stem

2 3

1

Place dark shape behind light edge to suggest underside of leaf in shadow

Draw fine lines over shape when dry to suggest veins

21

Combining tonal blocks and drawing

Here, we look at combining areas of tone and contrasting them with lines, drawn with the point of a brush, that follow the form of the object. Although the effects of coloured and tonal shapes are important in watercolour painting, it is also necessary to enhance images with the use of freely applied linear work at times – especially when the lines may suggest the presence of veins on the surface. When applied in a curve that follows the form of the subject, these lines help us to give the impression of a three-dimensional object. These exercises combine the 'on your toes' position of the brush with flat and angled strokes, the 'put' stroke and drawing.

Angles of application (1)

There are times, within a single brush stroke, where you may need to adjust the angle at which you hold your brush more than once.

Combining tone with line (2)

In this more complex image, based upon a seed pod, it is not only brush strokes that are considered but also relationships between tonal shapes and form finding lines.

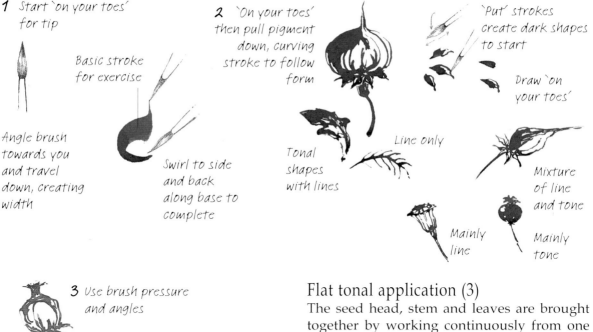

1 Start 'on your toes' for tip

Basic stroke for exercise

Angle brush towards you and travel down, creating width

Swirl to side and back along base to complete

2 'On your toes' then pull pigment down, curving stroke to follow form

Tonal shapes with lines

Line only

Mainly line

'Put' strokes create dark shapes to start

Draw 'on your toes'

Mixture of line and tone

Mainly tone

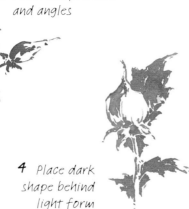

3 Use brush pressure and angles

4 Place dark shape behind light form

Flat tonal application (3)

The seed head, stem and leaves are brought together by working continuously from one into another to maintain even application. Use free-flowing pigment, diluted to achieve a pale hue, allowing it to be considered as an undercoat over which, when dry, further tonal shapes and drawing can be applied.

Using background images (4)

When images are grouped en masse, the lighter areas can be enhanced by what is placed beside or behind them. This exercise demonstrates the use of white paper to achieve this effect.

Blending

Blending, whether within the objects themselves or a background colour blended away from the objects to disappear into other colours or the white paper, is an exciting effect to achieve. The secret is to avoid adding too much water to the pigment already on the paper's surface – if you do, the point at which they meet may produce effects that are not the ones anticipated.

You can apply this blending technique to many subjects, including skies, where it can suggest the soft edges of clouds against the blue of the sky behind.

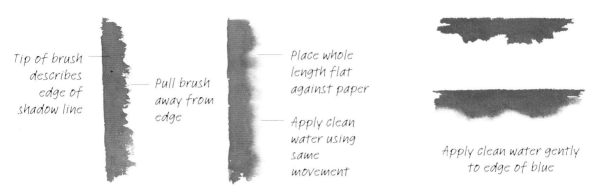

Tip of brush describes edge of shadow line

Pull brush away from edge

Place whole length flat against paper

Apply clean water using same movement

Apply clean water gently to edge of blue

Uses of blending

Blending can be used to great effect on both flat and curved surfaces. Consistency within a curve is important, and this is demonstrated in the subject of a tree trunk. The studies of foliage show the versatility of the misty and other effects that can be achieved by blending.

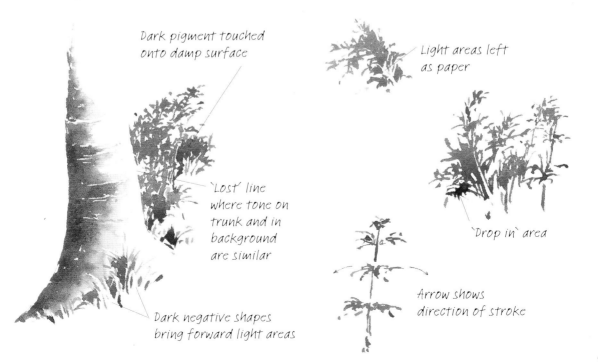

Dark pigment touched onto damp surface

Light areas left as paper

'Lost' line where tone on trunk and in background are similar

'Drop in' area

Dark negative shapes bring forward light areas

Arrow shows direction of stroke

Watercolour Techniques

Developing watercolour techniques through exercises can help to familiarize you with the amount of water you require to achieve certain effects. A common beginner's mistake is to add insufficient water to the pigment, or to not mix together enough in the palette to cover the intended area of paper – err on the side of too much, rather than too little, water.

Wet into wet

This technique, in which paint placed upon a damp surface spreads naturally, producing a diffusion of forms that find their own edges, helps to achieve a loose, soft effect. Used in the form of a muted background, it gives emphasis to more detailed work.

Painting wet into wet

The exercise below shows a basic wet-into-wet technique using one colour. Wet an area of paper evenly and hold the paper, angled, up to the light in order to observe the sheen and establish evenness.

Using a dilute mix of blue, commence drawing into areas of the damp surface with the tip of the brush. Watch the colour spread on contact. Work from side to side, and leave areas of white paper to suggest cloud shapes and formations.

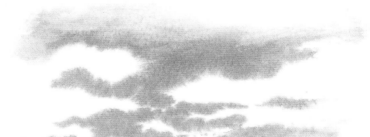

Darker areas can be placed over light

Single strokes applied at different angles

Test effect with single strokes on rough watercolour paper

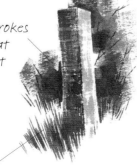

Use side of brush to achieve effect of long grass

Drybrush

A drybrush effect is often created accidentally at the end of a stroke when paint on the brush is drying rapidly. In order to create this effect intentionally, to give the impression of texture or muted highlights, you will need less liquid than usual in your brush. Drag the brush across the paper, depositing pigment upon the raised areas of rough paper but leaving the 'troughs' free of paint. A flat brush was used for this example.

Washes

The secret of successful watercolour washes is to allow the first wash to dry thoroughly before the next is applied. You need to build only a few glazed washes to intensify tone.

Flat wash

Load the brush with plenty of paint and, starting from the top, work down the paper from side to side using sweeping horizontal strokes, across one way and back in the opposite direction. Keep loading your brush as you work, to avoid an area becoming too dry to accommodate the following stroke.

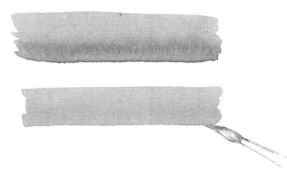

Gradated wash

To achieve a wash that progresses from a dark to light tone, add more clean water to the pigment for each successive stroke across the paper. To avoid creating a striped effect, experiment with the amount of water you add for each brush stroke line, and do not go back over a wash you have already laid.

Variegated wash

Choose two or three colours and blend one into the other as you work down the paper.

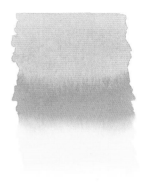

You can also create a wider band of the main colour and reduce the width for the second or third bands. When painting a sky, you can add clean water to the final strokes to suggest a light horizon.

Board angle

Support your paper – pinned or stretched upon a board – at an angle that will allow the brush strokes to flow into each other without causing dribbles.

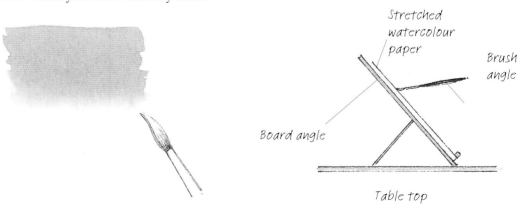

Stretched watercolour paper

Brush angle

Board angle

Table top

Highlights

Highlights are best depicted by the use of untouched white paper. Decide which areas are to remain white before you start to paint, and make preliminary sketches.

Painting around highlights

Sometimes pure white paper is not required for a painting, but a paler tone is. In this case, lifting off excess moisture and pigment is the answer, and the two techniques work well when used together.

This unfinished study of a prawn shows the underlying washes before subsequent layers of colour build up the intensity. Start by painting around the white area, as demonstrated in the study of peppers on page 12.

With no dark background, use a delicate line to bring the shape forward

Pull the paint away from the highlight and across the form

You can overlay pale washes after the initial shape has been defined

Removing excess moisture

Rinse brush in clean water, squeeze dry, then place tip onto wet surface to draw up moisture

Blotting Off

As long as you are using plenty of water mixed with pigment, if you make an error you can quickly blot the surface and significantly reduce the mark. Because watercolour lightens when it dries, the mark may be hardly noticeable and may be overpainted successfully.

Creating texture

The studies here show how blotting can be used to produce texture. Blotting produces subtle changes of tone with texture, and contrasts are essential for lively effects – gently drop darker pigment into damp textured areas. At all times keep the pigment fluid, paint onto a rough surface paper and blot gently. Be careful not to dry the blotted area too much, or the final stages may not take.

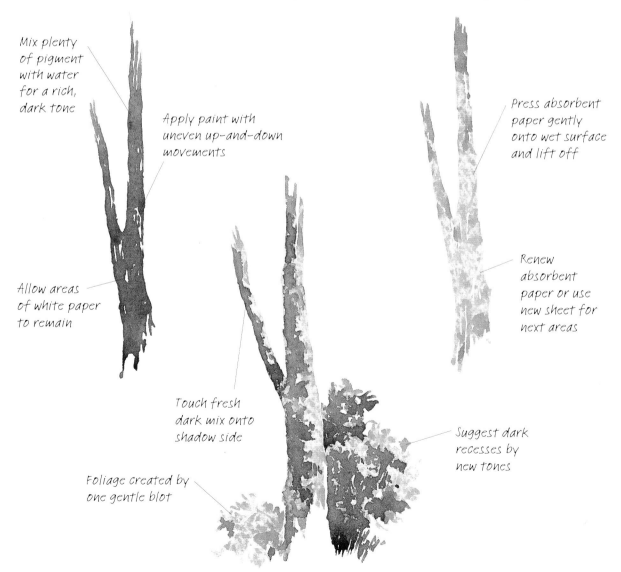

Mix plenty of pigment with water for a rich, dark tone

Apply paint with uneven up-and-down movements

Press absorbent paper gently onto wet surface and lift off

Allow areas of white paper to remain

Renew absorbent paper or use new sheet for next areas

Touch fresh dark mix onto shadow side

Suggest dark recesses by new tones

Foliage created by one gentle blot

Resists

A resist method is when part of the paper's surface is coated with a substance that prevents any overlaid washes of pigment reaching the paper underneath it.

Basic tree shape drawn using small brush dipped in masking fluid

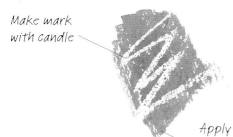

Wash of colour applied over dry masking fluid

Masking fluid

This fluid is applied to the paper with a brush or pen. It dries to a rubbery film over the areas covered, thus preventing paint from marking the paper. You can then paint normally around (or across) the masking fluid in the knowledge that once it is removed, the areas it covered will appear as clean paper. When the painting is thoroughly dry, you need only gently rub the fluid with a finger or pull the rubbery substance from the surface.

Make mark with candle

Apply colour wash

Candle wax

Rub a white candle gently across the paper, then apply paint over the area and watch how the waxed area resists the paint upon its surface. The texture produced using this technique can be used to depict many different surfaces.

Rocks among grass

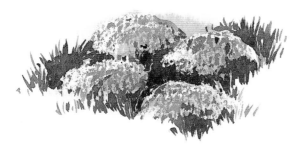

Draw shapes with the candle to represent smooth rocks, then sweep a wash of light colour over the waxed area. Any places where the wax did not touch the surface will take pigment in the usual way, as solid colour. Allow to dry before adding a darker tone to indicate shadow areas.

Creating Texture without Resists

Resists are not the only way to create texture in watercolour. Some techniques studied earlier, such as drybrush work and leaving highlights, can also be explored.

You can employ the surface of the watercolour paper to create texture – look at the texture of different brands of paper to see what it suggests.

Towelling, carpet and similar textures

Through this method, work 'on your toes' to follow the texture that can be observed on the surface of the paper.

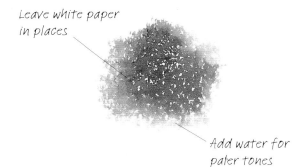

Leave white paper in places

Add water for paler tones

Wood grain

This overall textured effect is achieved by drawing a series of slightly uneven lines, one beside the other, using a brush.

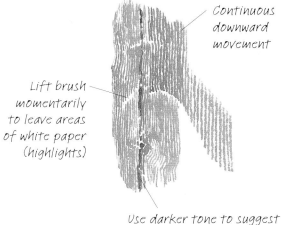

Continuous downward movement

Lift brush momentarily to leave areas of white paper (highlights)

Use darker tone to suggest recesses and shadow areas

Rusty iron

A rusty iron surface, with its cracks and indentations, can benefit from a stippling effect, for which you need to use the tip of your brush.

Apply base colour with swiftly applied angled brushstrokes

Cut in crisply to uneven areas with darker hue to suggest shadow recesses

Underside of leaf

This is a good example of how the surface of the paper can be used to great effect. Look closely at the paper's natural texture to note where the troughs occur. Apply the pigment in these 'pockets', leaving the raised areas as white paper.

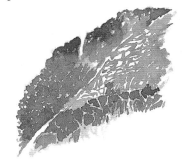

Understanding Colour

Colour enables you to create atmosphere in your paintings, and once you have mastered colour mixing you will be able to express moods better. By practising exercises you can learn which colours to use together and which combinations to avoid, and by experimenting you can understand all the ways in which you can make colour work for you.

Colour relationships

Colours affect each other – for example red and green, which are of equal intensity and are complementary colours, produce harmony when painted in equal proportions. By varying the proportions of these two colours within a painting you can create different effects. Paint a small square of green and surround it with a wide border of red. Compare this with a small square of red surrounded by a green border. Note how the green of the square appears lighter when surrounded by red, yet darker when green surrounds red.

The colour wheel

The basic colour wheel contains three primary colours, red, blue and yellow. Between them are the secondary colours, purple, green and orange. On more comprehensive colour wheels the intermediate colours are included – red-purple, blue-purple, blue-green, yellow-green, yellow-orange and red-orange – and the wheel can be subdivided again into further intermediates.

There is not actually a red, blue or yellow that is primary, as there are warm reds and cool reds. In the Winsor & Newton range an alizarin crimson or permanent rose is a cool red, whereas scarlet lake is a warm red; French ultramarine is a warm blue, and Winsor blue is a cool one; lemon yellow is cool, and cadmium yellow warm.

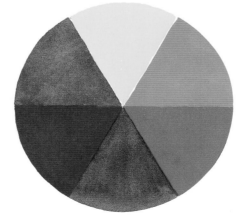

Tonal scale

As with the pencil scale in tone on page 15, we can also produce a tonal scale in colour. Paint the darkest value first then, adding a little more water to the pigment for each block, work through to the lightest tone.

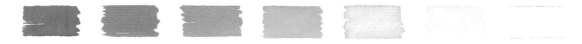

Limited palette

Decorative stonework –in the form of a window frame or a statue – is a subject which lends itself to execution in a limited palette or in neutral colours. The stonework around the window to the right was painted using three colours – burnt sienna, yellow ochre and cobalt blue – mixed in varying quantities and strengths. The subject on pages 32–33 was also painted using the same palette, to show that a very few colours can be adapted for totally different subjects.

Neutral colours

When the three primary colours are mixed together in certain proportions they produce a neutral hue. A range of neutrals was used in this painting of an angel statue.

Concentrated mix produces very rich dark to enhance shadow areas

31

Understanding Colour

Most watercolour paintings are created through a number of distinct preliminary stages. Try to become aware of, and think your way through these stages in your work. This will ensure that you are in control as the painting develops.

Establishing composition

Once you have chosen your subject, make a preliminary sketch, consciously looking for areas of interest. In the sketch below, the sheep on the ground, in neutral colours, blended into their surroundings, so I chose to concentrate more on the strong shadows cast across the trees.

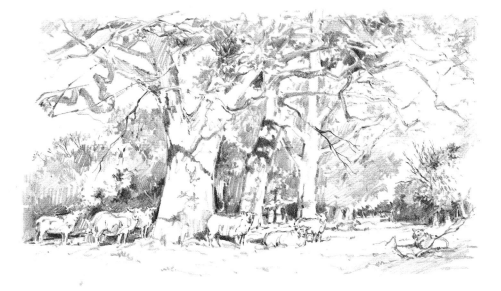

Drawing the tonal contrasts

A second sketch establishes the positions of negative and shadow shapes plus the areas of foliage mass. Once established, these basic shapes are then transferred onto watercolour paper as simple washes around the shapes of the trees.

Painting the main areas

The palette is limited to three colours that, combined in varying quantities, also produce a range of subtle neutrals. The clear blue of the sky provides a cool contrast.

Burnt sienna

Yellow ochre

Cobalt blue

Blended colours

Build up painting with freely applied blocks of colour and tone

Leave white paper to enhance contrasts

Blending

Crisp edges

Shapes between

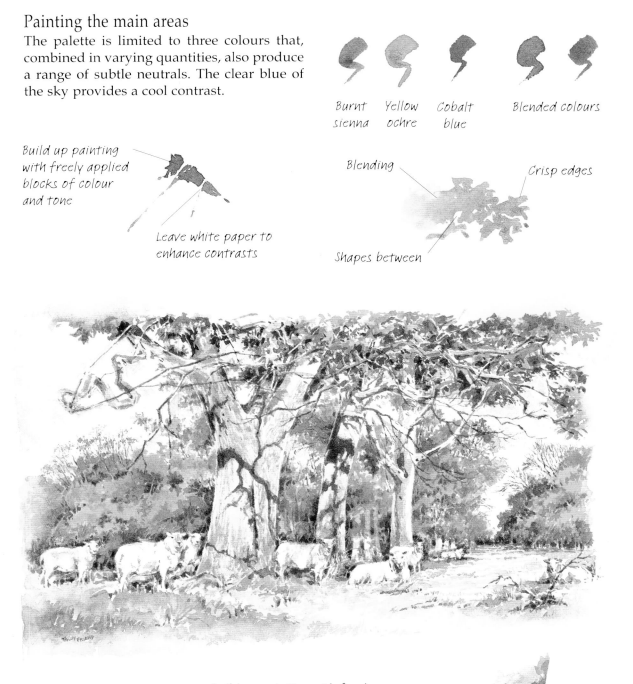

Build up painting with freely applied blocks of colour and tone

Leave white paper to enhance contrasts

To the Rescue

The disappointment felt when a promising painting goes wrong after hours of encouraging work can be reversed by the use of rescue techniques. The first thing to do is to assess the situation calmly and decide whether it is the drawing or paint application that is at fault. Excess paint can be washed off; images that have lost clarity can be redrawn over the watercolour using another medium, for example ink or charcoal pencil; gouache can be painted over watercolour to transform a weak painting; or a successful area of the artwork can be cut out of the whole and mounted separately.

Thick paint

If you have produced a painting where the paint has been applied too thickly, you can rescue it with a wash-off method. This method also helps when too much white is exposed within the painting, as it mutes the colours and enables you to build them up again, as well as giving you another chance to alter any drawing deficiencies.

Back to drawing

Making a drawing helps you notice things that need to be corrected, so draw in a 'painterly' way, using tonal masses rather than outlines.

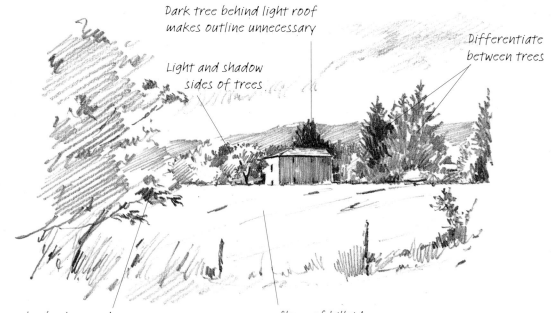

Dark tree behind light roof makes outline unnecessary

Differentiate between trees

Light and shadow sides of trees

Leaves overlay background

Slope of hillside

34

Washing paint off
Place your painting flat in a receptacle, and add clean running water. Gently stroke the surface with your finger, or brush or sponge off the pigment. Do this until there is no more pigment to be removed, only a residual tint staining the paper. Stretch the paper on a board and allow it to dry before continuing.

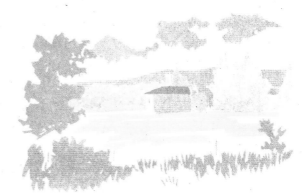

Cutting in and clarifying
Start by correcting the building, cutting in around the roof with a simple tree shape to give a dark colour behind and thus bring the image forward. Establish the shapes of the nearby trees.

Relating the foreground
Establish the relationship between the foreground and background by introducing the smaller trees on the other side of the building. This will enable the composition to become set.

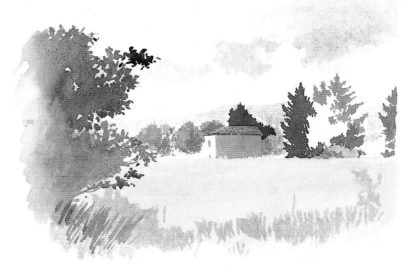

Final painting

Lightly apply washes to the grass area, to aid continuity. Build up the painting with washes in the foreground and background before adding the finishing details.

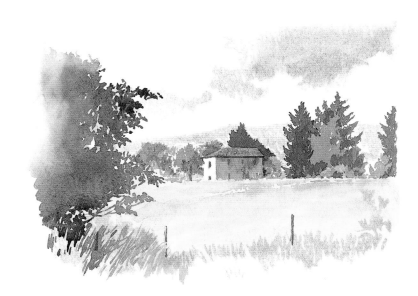

Using gouache

The problems with the painting above are the drawing (the right-hand side of the bridge slopes away too steeply), the greens (how to differentiate between them, and how much white paper to allow) and the muddled areas of shadow (the foreground area on the right-hand side is muddy and overworked, and lacks clarity within the shaded area). Gouache allows you to reintroduce drawing to correct and eradicate an unsuccessful sky. You can also use the advantage of working on a tinted ground to correct and to apply thicker paint to alter areas.

Establish areas of sky between redrawn branches and foliage

Lay warm (tint) wash over whole painting

Build up greens in relation to each other

Adjust tilt of picture and square off edges to lift bridge slightly, presenting more accurate perspective angle

Scraping off

When painting a snow scene, you may find you have coloured an area that you feel you would prefer to keep white. There may also be occasions where you wish to give the illusion of snowflakes, sea spray or sparkle upon a surface. In this instance, scraping off is part of the method to use; make sure that you use a sharp scalpel or craft-knife blade.

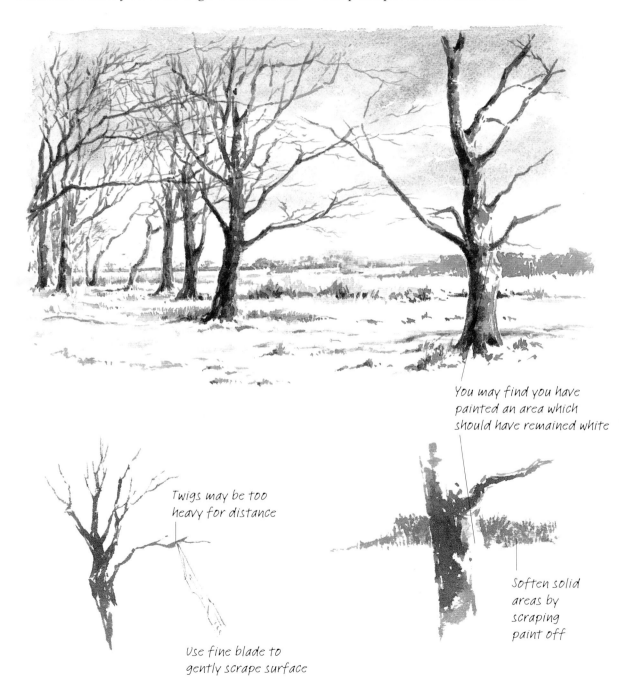

You may find you have painted an area which should have remained white

Twigs may be too heavy for distance

Use fine blade to gently scrape surface

Soften solid areas by scraping paint off

Rescuing scale and composition

If a painting's composition is becoming disjointed or you are having problems with relating the scale of one subject to another, you may find that excluding part of the picture is the answer. A simple method is to move a viewfinder around the picture until you find an area within the frame that presents a satisfactory composition, and then develop that area alone. If the painting was already completed and you were not satisfied with the overall effect, isolating a small area in this way can rescue hours of hard work.

Using mixed media

There are many examples of mixed media – watercolour and pastel, watercolour and charcoal, watercolour pencils and so on. One popular combination is watercolour and pen and ink, which is also an effective rescue technique because it allows you to clarify and re-establish the drawing aspect of your painting if this has been lost.

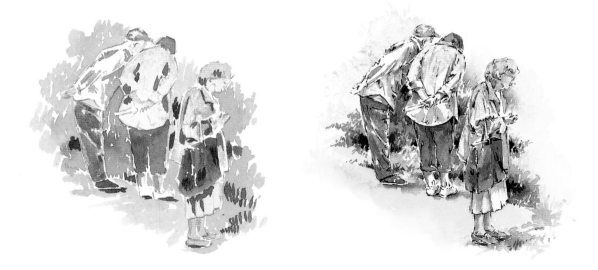

Skies and Water

Basic Brushstrokes

These exercises are designed to help you learn to interpret movement of water and clouds, allowing the surface of white watercolour paper to play as important a part as the paint itself. Also included here is a flat wash for when a tranquil sky or water surface is required.

Painting positions

The main brush positions for these examples are the normal painting angle (for flat brushstrokes) and one at a right angle to your hand (for the round brush image). Use a variety of angles for the cloud formation exercises shown below and opposite.

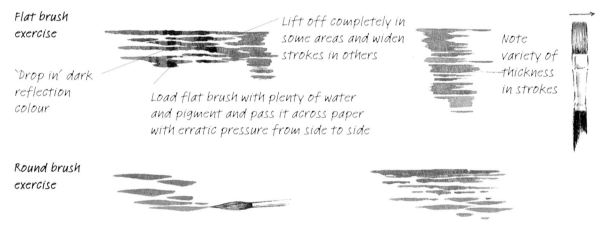

Flat brush exercise

'Drop in' dark reflection colour

Lift off completely in some areas and widen strokes in others

Load flat brush with plenty of water and pigment and pass it across paper with erratic pressure from side to side

Note variety of thickness in strokes

Round brush exercise

Hold brush at right angle to your body and touch, press as you travel and gently lift stroke

Make strokes narrower for distance, allowing to blend in places

Sky and water washes

Practise glazing with this simple exercise. Wash a block of pale blue onto your paper and allow it to dry. Mix a paler wash of a second colour, in this case raw sienna, and gently wash it over the blue to achieve a glazed surface.

Cumulus clouds

Apply pigment with curved strokes to describe the edge of a cloud (right), and paint out and away from the cloud (left).

Flat wash.

Blended with clean water

A variety of brush positions and directional strokes helps to create interesting cloud shapes.

Developing Brushstrokes

These four exercises are developments of the strokes shown opposite. Remember to remain aware of the movement aspect when portraying water and skies, as well as employing the juxtaposition of crisp and blended edges.

Reflected image

The flat brush exercise opposite is useful for broken reflections in rippling water. You can set it up yourself by placing an object that reflects onto water.

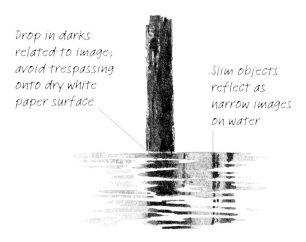

Drop in darks related to image; avoid trespassing onto dry white paper surface

Slim objects reflect as narrow images on water

Different viewing angles

Choosing a viewpoint near the surface of the water produces variations on how you portray the water and reflections on it.

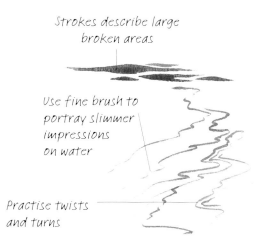

Strokes describe large broken areas

Use fine brush to portray slimmer impressions on water

Practise twists and turns

Blended wash

For painting tranquil skies you can create the desired effect by gradating a wash over another that has already dried (see page 25).

Paint a dilute raw sienna wash, allow to dry thoroughly, then paint a gradated wash over the first one

One-colour sky

You can practise painting cloud effects using only one colour. This is a development from the cumulus clouds exercise shown opposite.

'Pick up' pale blue from another area and paint slightly within light edge

Blend some clean water at cloud edges

Still Water: Typical Problems

To achieve spontaneity in your interpretation of water you need to restrict the number of washes applied. Without knowledge of the subject, however, adding washes at random cannot achieve satisfactory results – and nor can overpainting dark areas. You can see in the painting below how the background has been overworked.

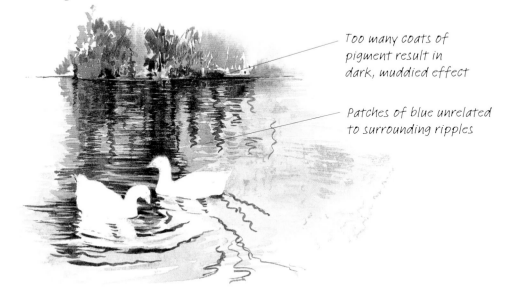

Too many coats of pigment result in dark, muddied effect

Patches of blue unrelated to surrounding ripples

Study detail using pencil

As water responds to its environment – stirred by a breeze or disturbed by birds, fish or amphibians, for example – it creates interesting patterns within reflections upon its surface. Start by observing and drawing these patterns on disturbed water.

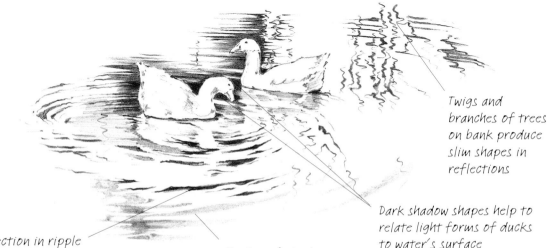

Twigs and branches of trees on bank produce slim shapes in reflections

Dark shadow shapes help to relate light forms of ducks to water's surface

Reflection in ripple

Shadow of ripple with no reflection

Solutions

An exercise in understanding

This exercise demonstrates wet-into-wet painting, representing distant reflections, and a controlled wet-on-dry interpretation for the close-up ripples.

Once you understand the subject and have interpreted it in this controlled way, you will be able to achieve spontaneity in your personal style.

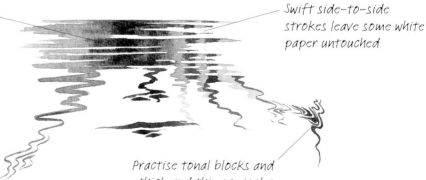

Paint around first pale wash

Apply masking fluid over duck images to allow sweeping strokes in background

Mask light images, allow to dry and apply washes freely

Paint in controlled way, following pencil shapes

While surface is still wet, 'drop in' dark reflection colour only on wet painted surface

Swift side-to-side strokes leave some white paper untouched

Practise tonal blocks and thick and thin squiggles

Moving Water: Typical Problems

The complexities of falling water against a backdrop of rocks, surrounded by ferns and other foliage, can be a daunting prospect for a beginner, as you are looking not only at an array of varying greens but also a vast variety of tonal contrasts. It is a good idea to separate one from the other and understand the importance of tonal relationships before moving into full colour – in this way it is possible to remove many of the problems that have arisen in the painting on the right.

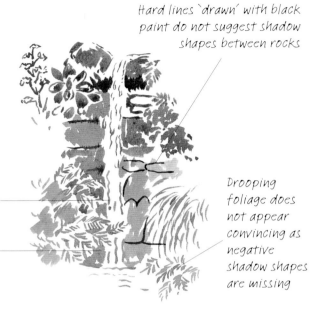

Hard lines 'drawn' with black paint do not suggest shadow shapes between rocks

Drooping foliage does not appear convincing as negative shadow shapes are missing

Random squiggles on white paper do not suggest falling water

Dark behind does not 'cut in' sufficiently around ferns

An opportunity for closer observation

Start by finding a subject that has water dripping or falling a short distance – this will not appear as complicated as a longer fall, and you will be able to observe and draw the way it flattens, twists and bubbles. Pay particular attention to tonal variations.

Darks between plant stems produce rich, reflected ripples, at first solid and later broken

Place areas of rich dark tone either side of falling water to make fall come forward

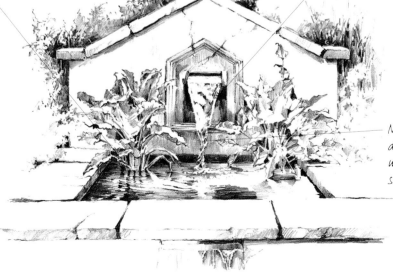

Note pattern of tone as water twists before meeting bubbling surface

Solutions

The magic of monochrome

Working in monochrome means that you put any problems of using colour to one side for the moment. This will allow you to take one learning step at a time. A number of points and methods mentioned in the Introduction have been used in this study, including applying masking fluid to retain light areas while allowing freedom of brush movements, using drybrush techniques for rough rock surfaces, enhancing dark negative shapes, and making full use of the tonal scale.

Making monochrome
Mix two colours together in plenty of water to create a pleasing neutral hue

Build up tone layer upon layer, allowing each to dry thoroughly

Paint on masking fluid in downward strokes to position waterfall

Lightly draw position of rocks and foliage masses in pencil

Block in foliage mass areas with masking fluid applied with small old brush, and allow to dry thoroughly

Use drybrush technique for textured areas

Gently remove masking fluid from all light areas and `cut in' a little with paint to reduce proportions

Cloudy skies: Typical Problems

Whether working wet into wet or using a rough, dry surface to produce interesting cloud edges, it is swiftness of paint application that achieves the best results – this may not be as easy as it sounds, because this way of working does not allow time to consider the effects that are being achieved during application. In many cases panic sets in and a series of uneven white blobs results, as seen below left.

Alternatively, wet paint placed on a wet surface without knowledge of the subject produces a pleasant effect, but not necessarily an impression of cloud formation.

Series of white
blobs within
one-colour
blue area

Random placing
of colours
without
knowledge of
cloud formations

Playing with paint

This exercise offers you the luxury of experimenting and pushing paint around without the concern of spoiling a painting. You will need a good-quality paper (see opposite). Choose your colours and mix each one separately, using plenty of clean water, in three separate palettes. Have other clean palettes ready for mixing colours together to create different hues.

Dampen the paper's surface with clean water. Either looking up at the sky, or at a photograph, paint the large shapes between the clouds. Make sure that the fluffy edges of the clouds that are to remain as white paper are interesting and appear natural. Mix some shadow colour and apply to the underside of the cloud formations.

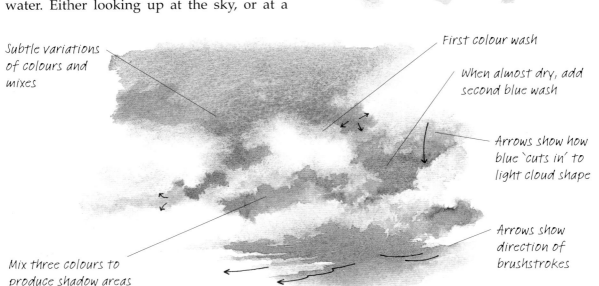

Subtle variations
of colours and
mixes

First colour wash

When almost dry, add
second blue wash

Arrows show how
blue 'cuts in' to
light cloud shape

Arrows show
direction of
brushstrokes

Mix three colours to
produce shadow areas

Solutions

Cumulus clouds

When cumulus clouds are nearer to you they appear fuller than those in the far distance. Note how the correct choice of paper helps you achieve desired effects – the surface of Saunders Waterford Rough 300gsm (140lb) paper is ideal to use for this technique, as the pigment settles into the hollows in the surface.

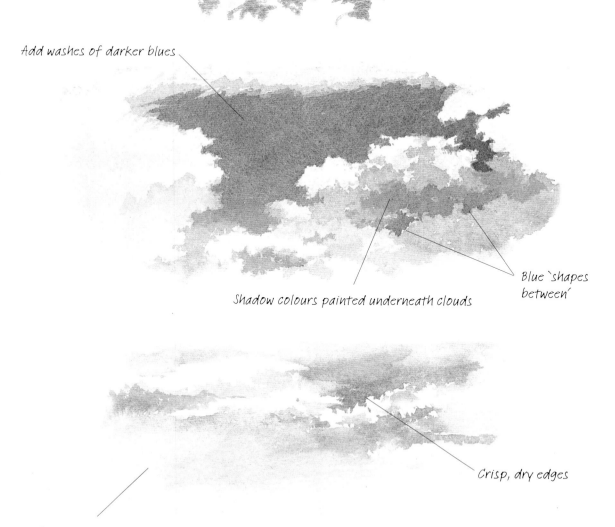

Pull first application of blue sky wash around white cloud shapes

Add washes of darker blues

Blue `shapes between´

Shadow colours painted underneath clouds

Crisp, dry edges

Blending wet into wet

Calm and Clear Skies: Typical Problems

Painting open landscape, or a wide expanse of sand and sea combined with a calm arrangement of clouds, gives you an opportunity to practise gradated washes, as shown on page 25. Let your hand and arm move smoothly from side to side, and always use plenty of water in your washes. Avoid hard edges (as seen in the painting below) if you want your skies to flow and blend with white, fluffy clouds.

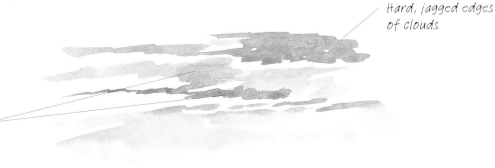

Hard, jagged edges
of clouds

Not enough
gradation in
sky colours

A soft style of drawing

To get a feeling of space and tranquillity you need to practise a calm approach to your painting and incorporate gentle blending. Use a heavyweight quality cartridge paper and 2B pencil drawing to create this effect and achieve a strong sense of perspective.

Producing a drawing like this gives you time to consider ways of suggesting subtle tones with light application of pencil pressure as you define the soft edges of the clouds – this should carry you into your painting in the right frame of mind.

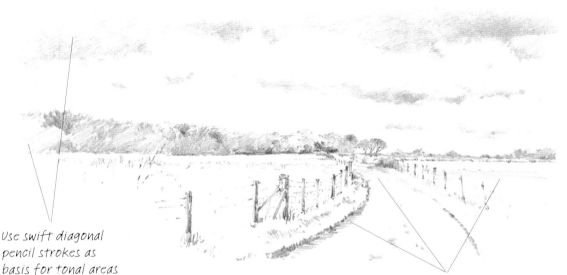

Use swift diagonal
pencil strokes as
basis for tonal areas

Use swift horizontal pencil
strokes as basis for tonal areas

Solutions

Gradated sky

Subtle gradations of colour and tone are essential for capturing the essence of a clear or calm sky. Note that the gradated washes in these exercises are shown darker than in the painting below, for the purpose of clarity.

For the raw sienna wash invert your paper and work away from the horizon line.

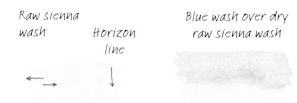

Raw sienna wash Horizon line Blue wash over dry raw sienna wash

With the paper the correct way up, start a blue sky wash and work down, adding more clean water as you approach the horizon.

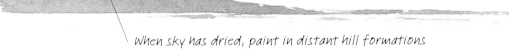

When sky has dried, paint in distant hill formations

Creating distance

In the painting below, the sky and distant coastline were painted first and allowed to dry. Darker foreground colours were then applied over the paler washes, and the sky was enhanced with cloud formations.

When dealing with painting styles that produce ragged edges, enclose the picture with a mount for a neater effect.

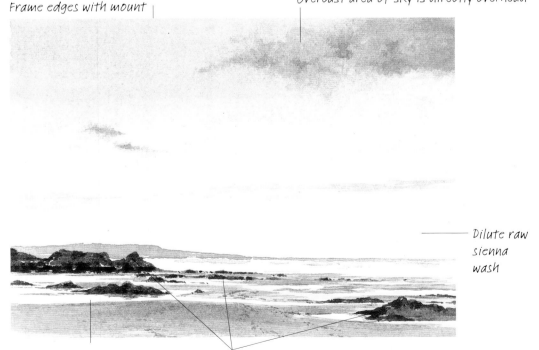

Frame edges with mount

Overcast area of sky is directly overhead

Dilute raw sienna wash

Water left as white paper

Paint dark foreground shapes over lighter washes

49

Trees and Foliage

Basic Brushstrokes

These exercises are designed to help you achieve a variety of brushstrokes that will enable you to depict different types of foliage and bark textures.

Creating a foliage mass

This shows you how to start a foliage mass, individual leaves and textured bark. Hold the brush vertically for this exercise.

Mix colours together to make green for foliage

Hookers green *Bright red*

Load brush with plenty of watery paint of rich colour

Place blob of paint on paper and push upwards using tip of brush

Directional leaf exercise

Hold the brush in a normal writing position for this exercise, but be prepared to vary the angle as you place individual strokes.

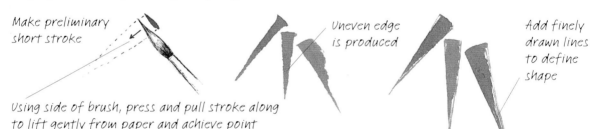

Make preliminary short stroke

Uneven edge is produced

Add finely drawn lines to define shape

Using side of brush, press and pull stroke along to lift gently from paper and achieve point

Bark effect exercises

The brush position varies for this exercise, using the positions shown above and combining them with other ones.

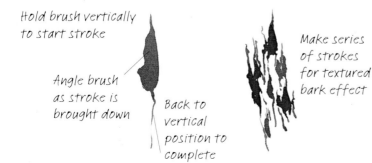

Hold brush vertically to start stroke

Angle brush as stroke is brought down

Back to vertical position to complete

Make series of strokes for textured bark effect

Basic bark stroke used horizontally

Repeat and curve to suggest dark delineations around tree trunk

Developing Brushstrokes

These four exercises are developments of the strokes shown opposite. Practise varying the pressure upon your brush and the angles at which you work, and you will quickly learn to achieve impressions of individual leaves and masses of foliage against tree barks.

Foliage mass for distant trees and bushes

An extension of the 'blob and push' exercise shown opposite, this exercise shows you how you can depict branches by pulling down individual strokes from a blob of paint.

Pull down individual strokes for branches

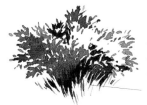

Make repetitive downward strokes for grass in front of low shrub

Long-angled leaves

This is an extension of the directional leaf exercise shown opposite.

Paint negative shapes seen between leaves

Paint additional leaves in darker tones

Creating light veins

More extensions of the directional leaf exercise opposite, the second of these combines pencil and watercolour work.

Make single curved travelling stroke

Repeat strokes alongside, leaving white paper between

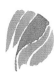

Bark

This extension of the textured bark effect opposite shows how you can create bark patterns on various trees, using shadow lines and shadow shapes. Use textured paper.

Establish basic texture with strokes demonstrated opposite

Draw with brush over raised areas and fill in tonal shapes to create pattern

Draw centre vein and side veins in pencil.

Paint between pencilled veins, allow to dry and erase pencil

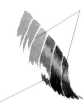

Add darker tones near central vein and at edge of leaf to create impression of highlight area

Distant Trees: Typical Problems

Distant trees often present a variety of problems for beginners as they try to depict massed foliage, individual branches and trunks of varying thickness. The latter, seen at a distance, may not be clearly visible and need to be understated rather than painted heavily. Remember that the colours of the leaves and trunks may not be as obvious when viewed from a distance as they are when placed in the middle ground or foreground.

1 Interpreted as scribble of paint. Too narrow at base.
2 Diagonally applied strokes with no regard for form. Branches do not join trunk.
3 'Square' blob. Base too wide for narrow trunk.
4 Unrelated blobs of paint. Lacking in structure.

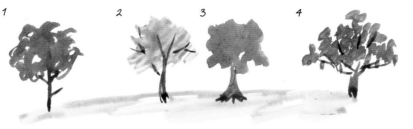

Sketchbook drawings

Use your sketchbook and make preliminary drawings to experiment with composition. In this drawing we see the view through an opening between bushes or hedgerows – almost as if the composition has a natural frame, that can be used in a painting.

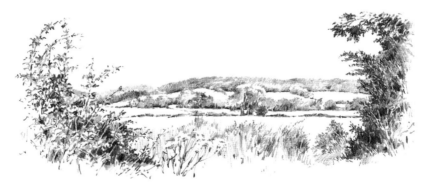

Open landscape

Although there is an indication in the foreground that we may be observing the distant view through sparse foliage, the composition is not contained and appears to stretch away without hindrance on either side, in contrast to the 'frame' in the drawing above.

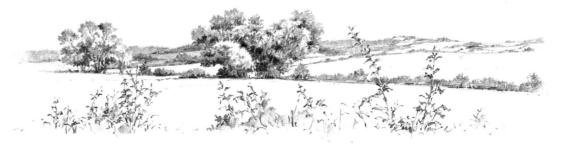

Solutions

Wet into wet

This technique uses the dampness of the paper surface to spread the first application of pigment. Make sure that you allow this to spread and dry enough to be able to control the later washes.

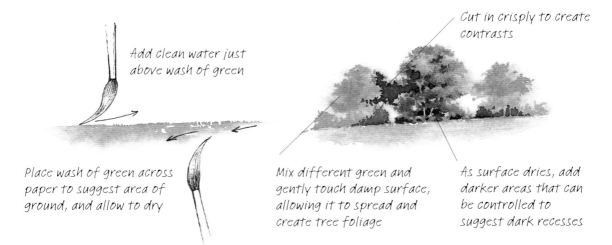

Add clean water just above wash of green

Cut in crisply to create contrasts

Place wash of green across paper to suggest area of ground, and allow to dry

Mix different green and gently touch damp surface, allowing it to spread and create tree foliage

As surface dries, add darker areas that can be controlled to suggest dark recesses

Blotting off

Taking up pigment and water with absorbent paper gives you a light base on which to drop in darker colours to produce a convincing impression of light and shade.

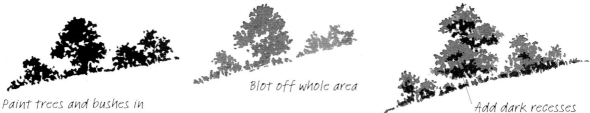

Paint trees and bushes in silhouette using dark, watery green

Blot off whole area

Add dark recesses and shadow areas

Building washes

After experimenting with the first two methods above you may feel more confident to tackle the method of building washes, one upon the other, allowing each to dry before the next is applied. This method can also incorporate the other two by blotting off in some areas if you feel this to be necessary, and by allowing some 'bleeding' of the paint (wet into wet).

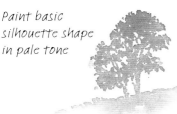

Paint basic silhouette shape in pale tone

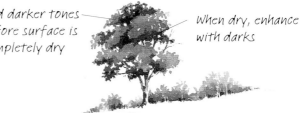

Add darker tones before surface is completely dry

When dry, enhance with darks

Masses of Foliage: Typical Problems

When painting masses of foliage, remember that you are not only trying to depict the prominent and obvious masses in the foreground but also those between and behind these masses. One of the most common problems experienced by beginners is of how to give the impression of density – too much white paper is often exposed, almost like a halo around some images. There are also problems with repetition – leaves in a mass are often placed one after the other, at identical angles and in a formal, unnatural arrangement – and lacking structure, where leaves do not appear to be anchored in any way. These problems may be seen in the painting below.

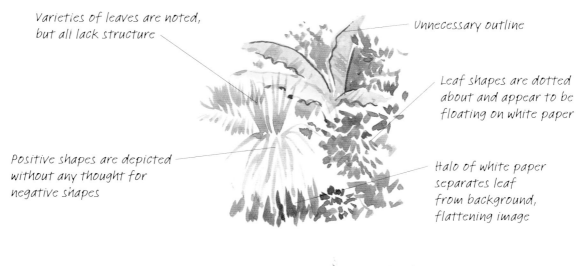

Varieties of leaves are noted, but all lack structure

Unnecessary outline

Leaf shapes are dotted about and appear to be floating on white paper

Positive shapes are depicted without any thought for negative shapes

Halo of white paper separates leaf from background, flattening image

Preliminary drawing

When observing a mass of foliage where different varieties are growing side by side, it is a good idea to concentrate on the largest, most obvious one first. Establish this then work away from the main mass, taking care to use any negative shapes between the leaves to place the leaves in correct relationship to each other. Note the amount of white paper – representing leaf shapes – that has been used in this study.

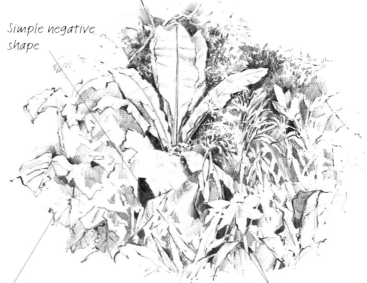

Simple negative shape

Start with loose drawing, tightening as you define shapes

Look for small negative shapes either side of stem

Solutions

Establishing the negative shapes

From closely observing where darker tones for the negative shapes between leaves and masses are depicted in the drawing, you will be able to create a medium-toned arrangement of these shapes. Practise a little study of one section to help you understand how this process works.

Draw leaf shapes in pencil

Paint in negative and shadow shapes

Developing the painting

The left-hand side of this study shows the 'undercoat' upon which the top layers are built. This comprises a series of negatives of various shapes and sizes, all in the same medium tone. Make sure that you colour-match the greens before you start painting, rather than midway through, as you are unlikely to make a match in the later stages.

Paint in negative shapes, allow to dry and erase pencil marks

Paint in cast shadows

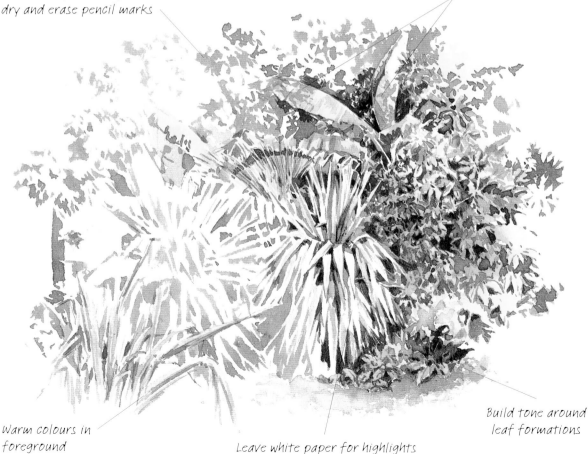

Warm colours in foreground

Leave white paper for highlights

Build tone around leaf formations

Individual Trees: Typical Problems

Beginners sometimes experience problems when trying to depict the structure of a single tree, especially when large areas of trunk and branches may be partially hidden by foliage masses. The structure then appears disjointed. Another problem is that of 'anchoring' the structure – the base of the trunk may be depicted as far too wide to give the correct proportions, or too narrow to support the structure above. Problems with treatment of the foliage occur when little thought is given to the direction of growth, resulting in a random placing of blobs of paint that do not represent leaves.

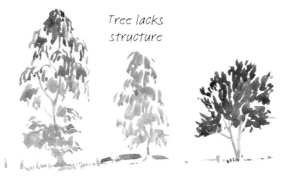

Tree lacks structure

Trailing leaves depicted with squiggle, not regarded as a mass

Foliage represented by blobs of paint

Using drawings to analyse problems

When you look at a painting and realise that something is wrong with the way that you have interpreted the subject, try to analyse the problem. Look at the edges of the tree silhouette and draw these as a flat pattern to start, then look within the mass and try to work out which areas appear light and which dark. Study the structure and leaf formations and determine the basic shape (silhouette) and growth pattern to familiarize yourself with the subject before starting to draw and paint.

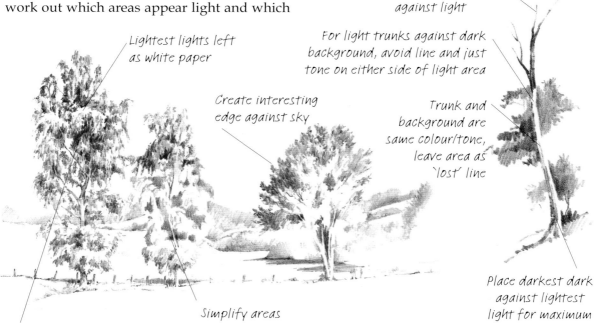

Lightest lights left as white paper

Create interesting edge against sky

Some areas are dark against light

For light trunks against dark background, avoid line and just tone on either side of light area

Trunk and background are same colour/tone, leave area as 'lost' line

Simplify areas

Look for dark recesses

Place darkest dark against lightest light for maximum contrast

Solutions

Working diagrammatically

You will be well on the way to solving many of your tree painting problems if you approach some of your drawings in a diagrammatic way, and when you start painting, do so in stages, as this will enable you to be in control every step of the way. Remember that drawing in a 'painterly' way and painting in watercolour are very similar in approach.

You need to use the white paper as part of the drawing/painting, so plan in advance which areas you intend to leave white or as light tones.

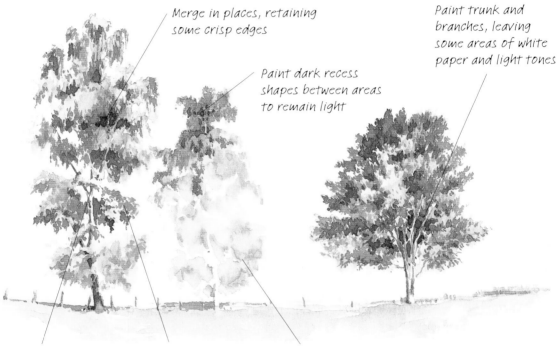

Merge in places, retaining some crisp edges

Paint dark recess shapes between areas to remain light

Paint trunk and branches, leaving some areas of white paper and light tones

Paint trunk and branches, leaving some areas of white paper and light tones

Add middle tones between darks and lights

Place shape of tree with diluted pigment, leaving white paper where sky and trunk show

Basic stages

Here, the method shown above is simplified to two basic stages. Look at a tree with a similar foliage mass silhouette to the first study and close your eyes a little, trying to see where dark masses show within the shape, as in the second study. The pale wash areas represent leaf masses touched by sunlight, and the dark shapes represent masses within shadow areas.

Paint first pale colour as silhouette block, and allow to dry

Paint in dark recesses and shadow areas

Leaf Shapes and Textures: Typical Problems

Whether you want to paint in a free or tight, detailed style, what can help achieve a feeling of confidence is the ability to create detailed impressions – you can always loosen up later. It is through a detailed approach that you can learn to really look at subjects and be fully aware of their unique structure and form. Because drawing and painting are so closely related, this spread shows how to combine the two within one study. In the same way,

you can combine watercolour pencils with watercolour for this way of working.

Fine foliage detail

One of the problems experienced by beginners with regard to detailed interpretations is that they may be too heavy-handed and this is not helped by the fact that often the pencil used is not sharp enough, or the brush does not have a sharp enough point for delicacy.

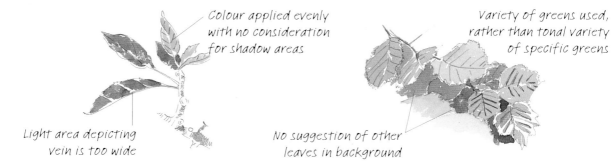

Colour applied evenly with no consideration for shadow areas

Light area depicting vein is too wide

No suggestion of other leaves in background

Variety of greens used, rather than tonal variety of specific greens

Drawing into paint

This illustration shows leaves in relation to fruit, contrasting the busy interpretation of the leaves with the simple, smooth surface that is found on apples.

You can see pencilwork on its own and areas of pure paint, but it is also interesting to carry one into the other and draw over your watercolour to add fine detail.

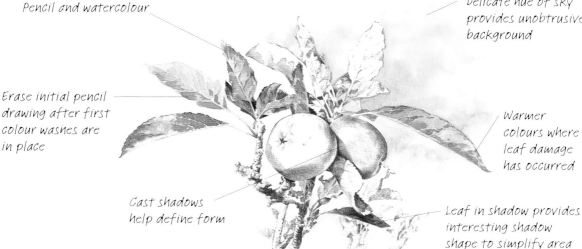

Pencil and watercolour

Delicate hue of sky provides unobtrusive background

Erase initial pencil drawing after first colour washes are in place

Warmer colours where leaf damage has occurred

Cast shadows help define form

Leaf in shadow provides interesting shadow shape to simplify area

Solutions

Complementary combinations

This study combines watercolour pencil and watercolour, with the former dissolving into the latter and becoming lost as the watercolour washes take over. For this type of detailed work, a smoother surface paper is more suitable than some of the textured or rough varieties.

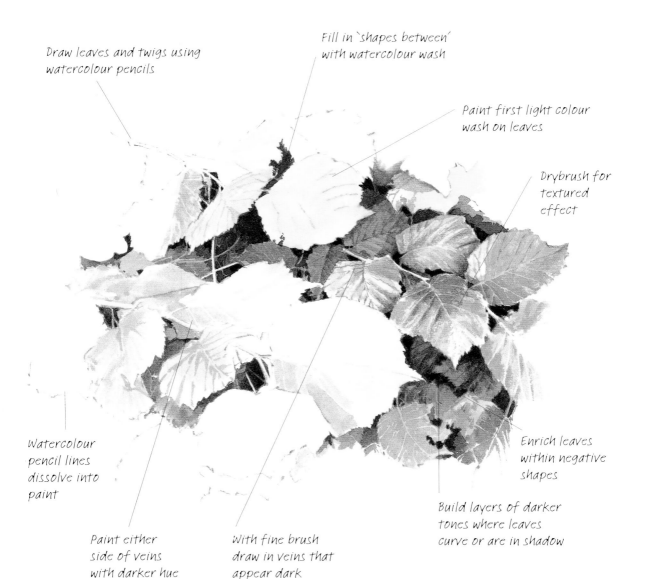

Draw leaves and twigs using watercolour pencils

Fill in 'shapes between' with watercolour wash

Paint first light colour wash on leaves

Drybrush for textured effect

Watercolour pencil lines dissolve into paint

Enrich leaves within negative shapes

Paint either side of veins with darker hue

With fine brush draw in veins that appear dark

Build layers of darker tones where leaves curve or are in shadow

Bark Texture: Typical Problems

The two obvious basic directions for bark texture – horizontal around the form, and vertical marks – have numerous variations (depending on the tree species) and can also play host to other textures. When painting light trunks it is a common beginner's mistake to draw outlines on both sides of the trunk. This, with horizontal strokes between edges, often results in a flat-pattern effect. The interesting contrasts of rough bark texture against smoother surfaced growths within a recess, provide opportunities for the inclusion of rich darks, resulting in full use of the tonal scale. One beginner's problem is how to use tones to full advantage – and an abundance of white paper, with a few dark blocks and squiggles, can be the result.

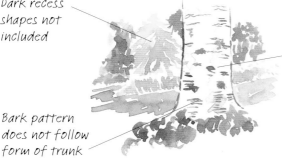

Dark recess shapes not included

Bark pattern does not follow form of trunk

Shadow area placed without regard to contours of trunk

Darks appear as superficial marks rather than shadow areas

Put your thoughts on paper

It is helpful to approach these problems diagrammatically, by putting your thoughts on paper. For example, if you look at an area of tree bark directly in front of you and determine which texture line is exactly horizontal (on your eye level), you will notice that when you raise your eyes slightly (above your eye level) the bark texture lines curve downwards. Alternatively, when you lower your gaze they sweep upwards. This observation can be drawn onto the paper as an arrow or, as below right, a series of arrows.

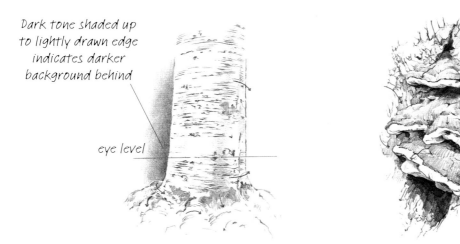

Dark tone shaded up to lightly drawn edge indicates darker background behind

eye level

Thought arrows show directions in which to apply tone to follow form

Solutions

Contrasting bark textures

Here, a detailed, botanical-style illustration – where precision is of great importance – is contrasted with a looser style, used to depict a rough-textured bark with fungal growths.

This detailed style of drawing and painting encourages close observation and is best used to make precise marks depicting a species that should not be mistaken for another.

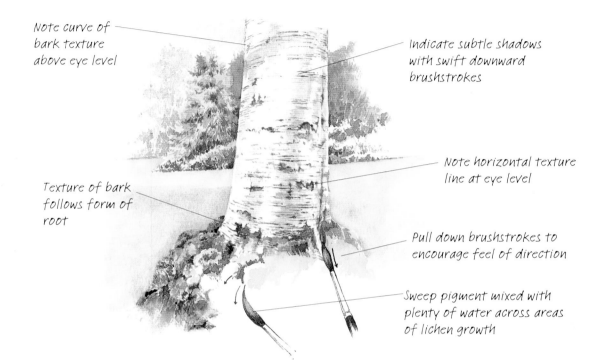

Note curve of bark texture above eye level

Indicate subtle shadows with swift downward brushstrokes

Texture of bark follows form of root

Note horizontal texture line at eye level

Pull down brushstrokes to encourage feel of direction

Sweep pigment mixed with plenty of water across areas of lichen growth

Using a loose approach

Rough-textured bark with interesting fungal growths can be depicted with a loose style of painting. This does not mean that it should be any less carefully observed, however, rather that observation should take in the fact that this surface possesses deep recesses with growths coming towards us.

Establish the darker recess, and the areas that are to remain as white paper, by painting around the shapes in medium tone. Slowly build up the intensity of tone and colour, wash upon wash, enhancing the fine details by enriching tonal contrasts (darkening the darks against much lighter areas) and drawing shadow lines with the brush.

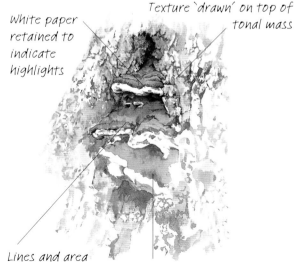

White paper retained to indicate highlights

Texture 'drawn' on top of tonal mass

Lines and area of tone follow form

Blending wet into wet

Flowers

Basic Brushstrokes

These exercises are designed to help you place leaf, petal and stem strokes with confidence – whether on detailed specimens or in a freely painted group. On this page the basic strokes in isolation are shown, and on the opposite page, you can see how they can be developed within a painting.

Mix and match
Mix the three primary colours in different proportions to achieve a variety of subtle colours and neutral hues.

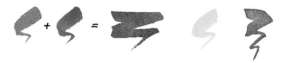

One-stroke shape
This is the basic 'touch, press as you travel, lift and twist' stroke seen on page 20. The first stroke is upwards, the second downwards.

Touch tip of brush vertical to paper and angle end away from you

In normal painting position, place brush tip on paper and pull stroke down towards you

Pigment accumulates at end of stroke away from starting point

Short, curved strokes
A series of curved strokes, indicated by arrows, follows one after the other. Load the brush with plenty of water and pigment.

With brush position a little more vertical than normal, describe strokes using directional application

Positive and negative silhouettes
Use the normal painting position for these three exercises.

Touch tip of brush placed vertical to paper and angle end away from you

One stroke 'press and lift' line
Use a standard working position to make a 'touch/ travel, press to expand, then lift' stroke.

Place another stroke below, leaving thin strip of untouched paper between

Draw around similar shape using very fluid pigment

While still wet, add clean water to blend pigment away from original outline

Developing Brushstrokes

These four exercise variations are developments of the brushstrokes shown opposite. All were painted on a Rough-surface paper, upon which you should be able to achieve fine lines if you use a good-quality brush that enables you to work with a fine point.

Leafy stem
This is an extension of the 'touch, press as you travel and twist as you lift' stroke.

Fine pattern lines can be carefully superimposed over basic shape when dry

One-stroke blending
This is an extension of the one-stroke 'press and lift' exercise. Note that a darker hue has been touched against a still wet area to produce a darker blended area.

Add clean water for pale colour blending

Mass of petals
This is an extension of the short, curved strokes exercise opposite. Remember the basic flower shape as you work.

Work quickly, placing strokes in directional way

Retain some white paper within stroke for this effect

Basic backgrounds
This is an extension of the positive and negative silhouettes exercise.

Leave white paper to intrude at base of leaf shape for edges of flower petals

Add shapes to suggest foliage/stems once blended area has dried

Solid silhouette shapes can be helpful for certain effects

Flower image to be painted here

Paint negative shapes only and blend away edges with clean water

Simple Shapes: Typical Problems

The strong delicacy of lilies, where crisp crinkled edges of tapering petals can be clearly seen against the rich dark leaf shapes, provides a contrast to the more fragile rose on page 66.

Here, simple trumpet shapes burst open to display their array of stamen around the central pistil, but it is this very arrangement that can prove to be problematic for beginners.

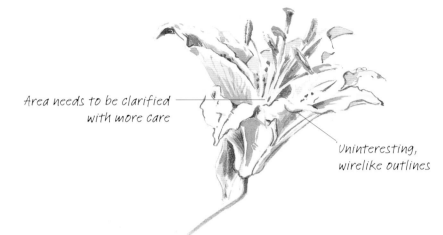

Area needs to be clarified with more care

Uninteresting, wirelike outlines

Beginning with a bud

This detailed drawing of a lily bud demonstrates how close observation can teach you much about structure and relationships. By drawing a single bud first you can begin to understand how the petals eventually open up to reveal the glory within.

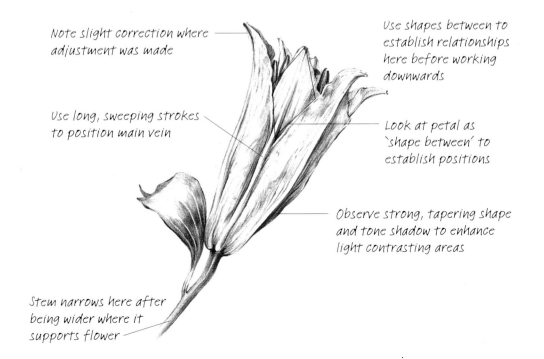

Note slight correction where adjustment was made

Use shapes between to establish relationships here before working downwards

Use long, sweeping strokes to position main vein

Look at petal as 'shape between' to establish positions

Observe strong, tapering shape and tone shadow to enhance light contrasting areas

Stem narrows here after being wider where it supports flower

Solutions

From drawing to painting

The main shapes in this study were drawn in both graphite and watercolour pencils on a Rough-surface paper before watercolour was added. The combination works well and enhances blending techniques.

Note that the lower area demonstrates the first stages of the painting, where more emphasis is placed upon the background (negative) shapes to provide form to the lighter flowers.

Note scale of stamens in relation to petals

Tiny negative (shadow) shapes on either side of stem automatically place bud or leaf in correct position

Important negative shapes place two sets of flower heads correctly in relation to each other

Central components 'burst out' like fireworks

'Cut in' crisply with neutral background colour to bring white petal images forward

More Complex Shapes: Typical Problems

Delicate flowers can be painted in a free style, but they will still rely on close observation and drawing ability if your paintings are to be convincing. When painting pale colours, beginners often resort to outlining petals or placing contrasting colours behind the image.

Both of these methods are acceptable when they are used correctly, but they need to be applied carefully. In the painting below, the artist has been rather heavy-handed for such a delicate subject – a miniature rose with fine, detailed leaves and petals.

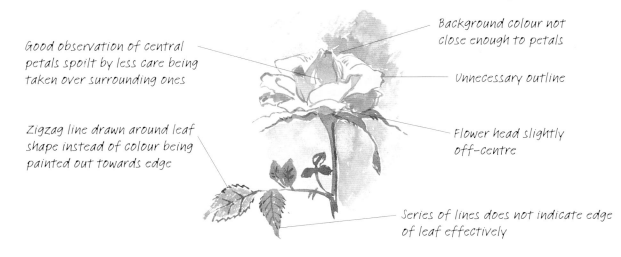

Good observation of central petals spoilt by less care being taken over surrounding ones

Zigzag line drawn around leaf shape instead of colour being painted out towards edge

Background colour not close enough to petals

Unnecessary outline

Flower head slightly off-centre

Series of lines does not indicate edge of leaf effectively

Diagrammatic drawing

This sketch of a rose is not intended as a finished drawing but rather as a finding-out exercise. The lines around the edges have been enhanced more than usual, to help you understand the shapes and reinforce your knowledge prior to painting.

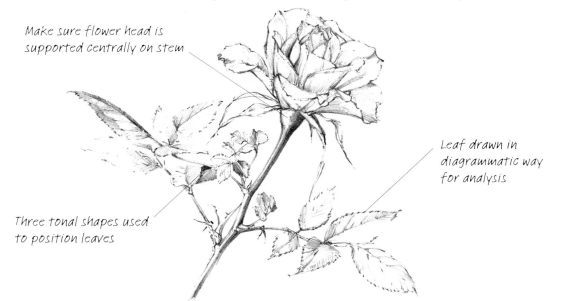

Make sure flower head is supported centrally on stem

Three tonal shapes used to position leaves

Leaf drawn in diagrammatic way for analysis

Solutions

Colour and form

Saunders Waterford 300gsm (140lb) Not paper was used for this subject, as it encourages free application while allowing fine detail to be achieved. In addition, gentle blending of background colours, that 'cut in' to describe the form, can help you to capture the essence of a rose.

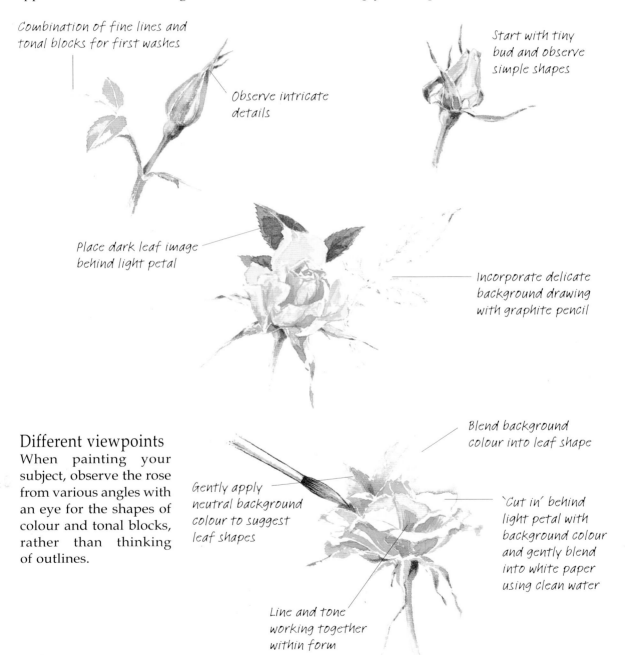

Combination of fine lines and tonal blocks for first washes

Observe intricate details

Start with tiny bud and observe simple shapes

Place dark leaf image behind light petal

Incorporate delicate background drawing with graphite pencil

Different viewpoints

When painting your subject, observe the rose from various angles with an eye for the shapes of colour and tonal blocks, rather than thinking of outlines.

Gently apply neutral background colour to suggest leaf shapes

Blend background colour into leaf shape

'Cut in' behind light petal with background colour and gently blend into white paper using clean water

Line and tone working together within form

Palm and Bamboo Types: Typical Problems

The smooth surface of long, tapered leaves, particularly those of palms or bamboo types, comes as a contrast to the freely applied brushstrokes on the previous pages. Tradescantia leaves, although shorter, require similar treatment – long, sweeping brushstrokes from tip to base or vice versa. The studies on this page have been treated in a tighter, more controlled way, as it is the long slender lines that are important.

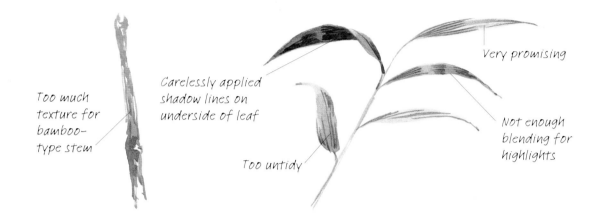

Too much texture for bamboo-type stem

Carelessly applied shadow lines on underside of leaf

Too untidy

Very promising

Not enough blending for highlights

Varied pressure drawing
Random, long leaf exercises give you the opportunity to practise 'press and lift' strokes with your pencil prior to starting brushstroke work, helping you learn how to create highlights.

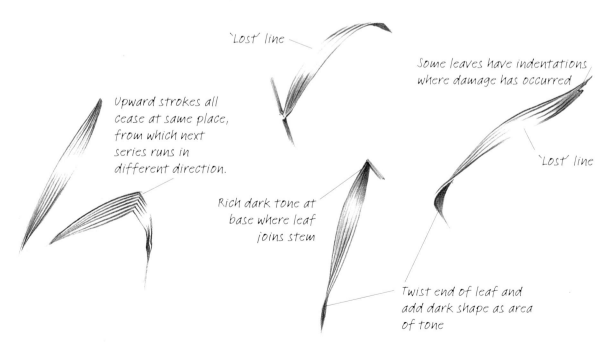

'Lost' line

Upward strokes all cease at same place, from which next series runs in different direction.

Rich dark tone at base where leaf joins stem

Some leaves have indentations where damage has occurred

'Lost' line

Twist end of leaf and add dark shape as area of tone

Solutions

Lines on leaves

Tinted Bockingford paper is ideal for the basic sweeping strokes and thin lines of pattern in the leaves' surface – the paint flows on easily for the wider leaf shape, yet narrow lines can be just as successfully achieved upon this versatile surface, using a fine brush for the delicate points on long, tapering leaves. The surface of this paper also responds well to blending and, because it is tinted, background washes merge successfully into the tint.

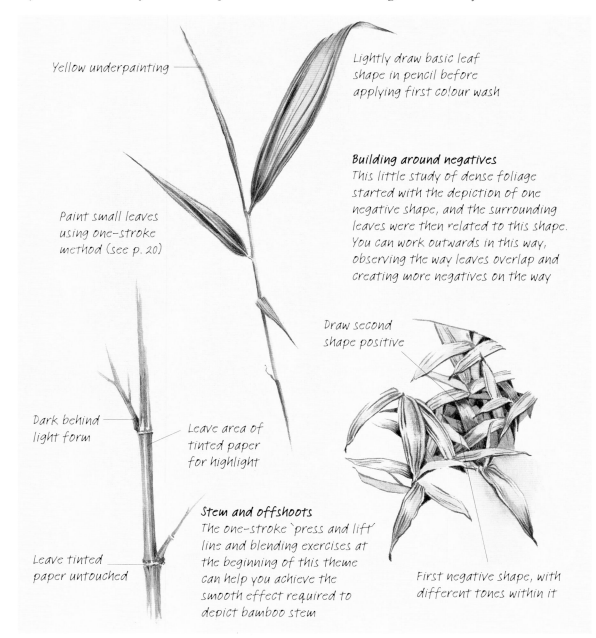

Yellow underpainting

Lightly draw basic leaf shape in pencil before applying first colour wash

Paint small leaves using one-stroke method (see p. 20)

Building around negatives
This little study of dense foliage started with the depiction of one negative shape, and the surrounding leaves were then related to this shape. You can work outwards in this way, observing the way leaves overlap and creating more negatives on the way

Draw second shape positive

Dark behind light form

Leave area of tinted paper for highlight

Leave tinted paper untouched

Stem and offshoots
The one-stroke `press and lift' line and blending exercises at the beginning of this theme can help you achieve the smooth effect required to depict bamboo stem

First negative shape, with different tones within it

Bouquets: Typical Problems

A floral bouquet supplies a profusion of brightly coloured flower heads set against rich greenery. Light forms are thrown forward, creating crisp contrasts that rely upon a juxtaposition of interesting shapes to create the composition, and masses of stems and leaves behind the main flower heads provide contrasts of colour, tone and form. Beginners are often unsure how to depict this greenery, as well as the intricate petals of the blooms.

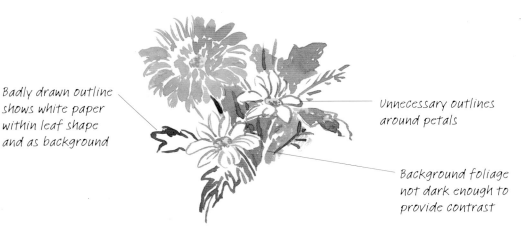

Badly drawn outline shows white paper within leaf shape and as background

Unnecessary outlines around petals

Background foliage not dark enough to provide contrast

Drawing the details

It is a good idea to familiarize yourself with the structure of the flower heads – this can be achieved by drawing details in order to analyse the forms. You can choose to draw the individual leaves and petals, or one or two in relation to each other.

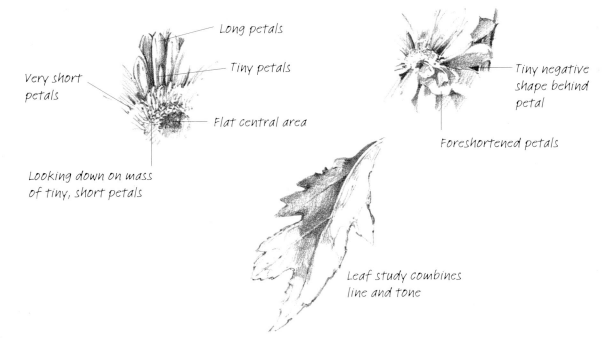

Long petals

Tiny petals

Very short petals

Flat central area

Tiny negative shape behind petal

Foreshortened petals

Looking down on mass of tiny, short petals

Leaf study combines line and tone

Solutions

Working from within

An exercise that encourages close observation is that of working from within a group of flowers, rather than arranging the composition as shapes around a central area or drawing them at random. Start with a single flower head and relate another to it. Add dark leaves and shadow shapes behind, and continue to work outwards and away from the initial shapes. Saunders Waterford 300gsm (140lb) Not paper is ideal for the gentle blending technique here.

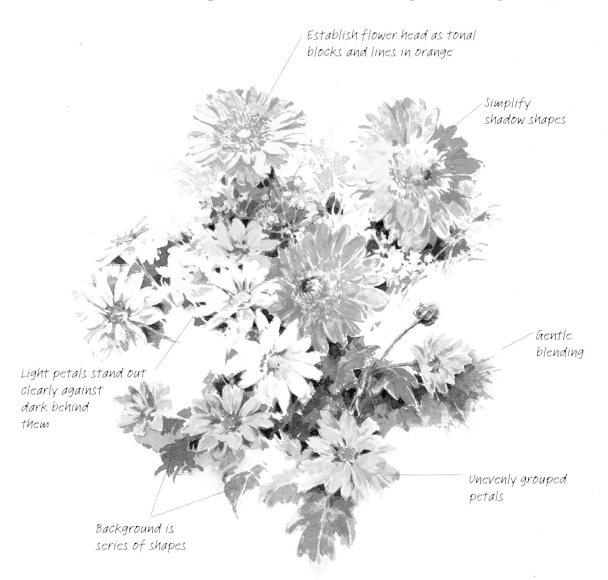

Establish flower head as tonal blocks and lines in orange

Simplify shadow shapes

Gentle blending

Light petals stand out clearly against dark behind them

Unevenly grouped petals

Background is series of shapes

Garden Scenes: Typical Problems and Solutions

A garden scene, with flowers and foliage creating a 'busy' painting, can benefit from the introduction of animal life. However, having decided to introduce an animal, some beginners then face the problem of where to place it and what colour to paint it. It is also important to consider both the composition of the painting and how to make the animal clearly visible amongst the foliage. These problems have arisen in the painting below, where the grey tabby cat is 'lost' and not an obvious focal point as intended.

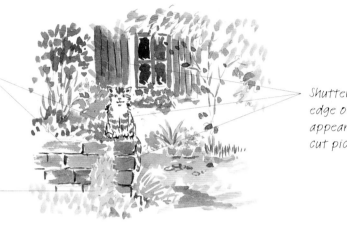

Grey of tabby and stone
wall are of similar,
undifferentiated hue

Shutter, cat and
edge of wall all
appear in line and
cut picture in two

All foliage similar and
appears disjointed

Considering the cat

By changing the animal's stance within the composition you can break the line from the shutter downwards. You can also increase the shadow area behind the cat to bring its form forwards.

Include more intense
shadow shapes to create
strong background

Leave part of cat as white
fur to simplify and make
form more obvious

Draw in painterly way, with
random directional marks
suggesting background

Solutions

Improving the pictorial composition

You can make amendments throughout the picture, but often just one or two small changes can make all the difference. Here, deciding to change the cat's colour to ginger and white, added to its new, animated and therefore more lively position, immediately improves both the composition and clarity of the painting.

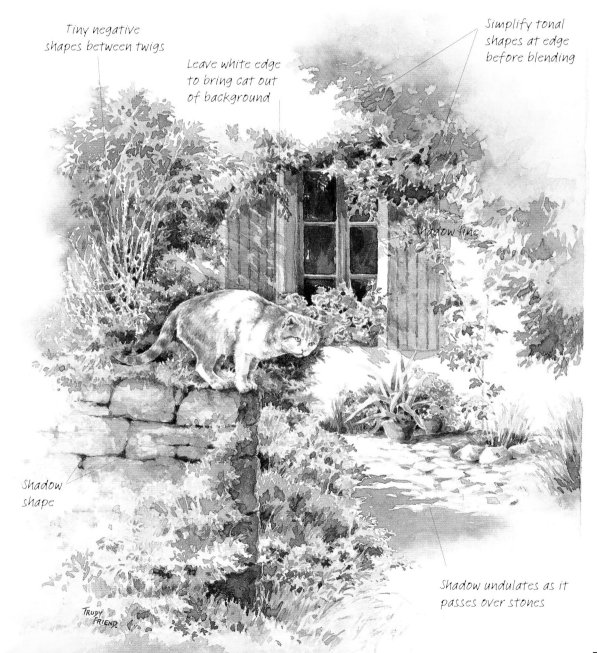

Tiny negative shapes between twigs

Leave white edge to bring cat out of background

Simplify tonal shapes at edge before blending

Shadow line

Shadow shape

Shadow undulates as it passes over stones

TRUDY FRIEND

Fruit and Vegetables

Basic Brushstrokes

The following exercises will help you to create textured effects for fruit and vegetables, with repetitious strokes for close texture and sweeping strokes for smoother surfaces.

When used on a Rough-surface paper, some sweep and curve strokes automatically leave areas of white paper that suggest highlights, such as on the surfaces of citrus fruits.

'On your toes' painting position

This stroke pushes paint outwards unevenly and is good for depicting the uneven, rough texture of citrus fruit skins.

Make uneven blob and push paint outwards, using texture of paper as guide

Warm red　　Green

Mix to create versatile colour

Add water to edges to blend and place tiny dots for indentations before blended area has fully dried

Place, sweep and curve stroke

This stroke, with the brush held at less of an angle, is suitable for depicting curved surfaces where shadow sides and highlights are required, for example on root vegetables such as carrots and parsnips. Note that some areas are solid colour, with white paper cutting in. White (highlight) areas have contour lines drawn with a brush.

Make basic stroke following direction of arrow

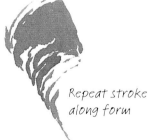

Repeat stroke along form

Standard writing position

This looped stroke is suitable for depicting the fleshy, teardrop-shaped components of citrus fruit segments.

Make stroke following direction of arrow

Repeat and mass for citrus fruit segments

Repeat, flattening strokes, to suggest inside surface of pepper

Developing Brushstrokes

Here, you can see how the brushstrokes shown opposite have been developed and adapted to create the textures used in the fruit and vegetable theme overleaf.

Always study your subject closely before starting to paint, as in this way you will establish brushstroke direction by following form and texture.

Citrus fruit skin
The curved surface of citrus fruit requires areas of highlight and shadow to give the impression of a three-dimensional form. This is an extension of the 'on your toes' exercise opposite. The edge of the fruit has been added, as well as the position of the highlights and blending to dot in recesses.

Carrots and other root vegetables
The main texture of these vegetables can be created easily within the sweep of the brushstrokes as they travel down the form, where white paper shows through pigment in places. This is an extension of the place, sweep and curve stroke.

Leave white paper for highlights

Add dots for indentations

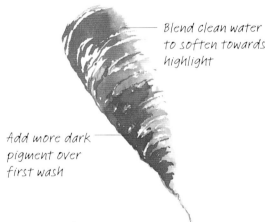

Blend clean water to soften towards highlight

Add more dark pigment over first wash

Highlights on internal segments
These repetitive, looped strokes form a mass to represent areas of highlight and shadow on a cut, flat surface or side of a separated citrus segment, as well as the internal texture of a pepper. This is a more delicate interpretation of the place, sweep and curve stroke, and can be tightly looped.

Texture inside casing
The inside casing of certain fruits, vegetables and in many cases nuts can receive the same treatment as demonstrated in the pepper example below. This is another adaptation of the basic looped stroke.

Draw fine lines rather than wide strokes

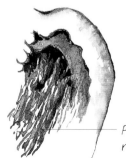

Point both ends of repeated strokes

Add clean water to blend in places

Cross-Sections: Typical Problems

A solution to many drawing and painting problems is to develop a deeper understanding and knowledge of your subject. For example, when observing the outer casing of a fruit or vegetable, it is sometimes difficult to imagine what lies within. Discovery leads to enlightenment, and you can build up self-confidence by drawing and painting cross-sections – these will present you with exciting, and sometimes surprising, patterns and textures.

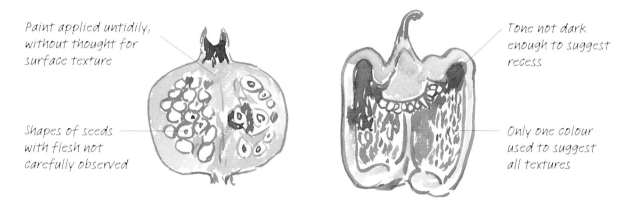

Paint applied untidily, without thought for surface texture

Shapes of seeds with flesh not carefully observed

Tone not dark enough to suggest recess

Only one colour used to suggest all textures

Drawing the details

First draw a segment of a vegetable or fruit – such as the pomegranate on the left or the bell pepper (capsicum) on the right – and then note how the seeds are contained.

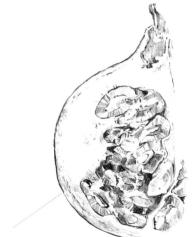

Hard outer casing – hard line

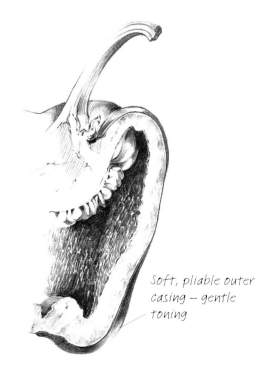

Soft, pliable outer casing – gentle toning

Solutions

Pattern with texture – pomegranate

Be guided by weight before cutting fruit in half. The solid feel of a pomegranate will suggest the contents – numerous seeds encased by flesh. The individual shapes are dictated by the close proximity of the neighbouring ones, making interesting patterns and textures. Note how the two halves of this cross-section are different in content and arrangement.

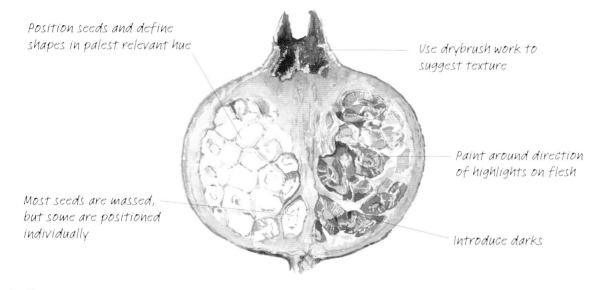

Position seeds and define shapes in palest relevant hue

Use drybrush work to suggest texture

Paint around direction of highlights on flesh

Most seeds are massed, but some are positioned individually

Introduce darks

Bell pepper

The lighter weight of a bell pepper suggests a hollow interior. The uniformly shaped seeds cling to the fleshy area at the base of the stem and are surrounded by space.

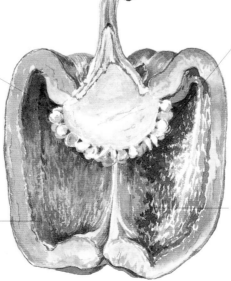

Use dark areas to enhance clarity and shape of seeds

Make up textured area by building up `dry' tonal washes

Pull and curve brushstrokes to follow form

Rough-surfaced paper plays important part in creating white highlights

Three Dimensions: Typical Problems

As the images shown below demonstrate, the most common problem encountered by beginners in drawing and painting fruit and vegetables is creating something that looks three-dimensional. Although you are inevitably working with a limited palette, you also need to be sure you look for subtle colour variations to achieve a realistic rendition.

Image drawn in outline

Veins too heavy and do not follow form of onion

Roots spread out; allowing strands to overlap would look more natural

Edges of highlight too hard

Unintentional halo of white – background colour should `tuck in' more closely

Flat colour would benefit from subtle blending

Veins have `bled' because paint was applied before underlying wash had dried

Subtly drawn three-dimensional forms

Look at this drawing to see how some of the problems shown above have been rectified.

Softened highlights and tonal variations create three-dimensional image

Contrast busy area with one that `rests the eye'

Draw roots as light images against dark and dark against light background

Negative shape between three objects allows you to place each one correctly in relation to others

Make use of shadows cast across area of background

Shadows follow form upon which they are cast

Solutions

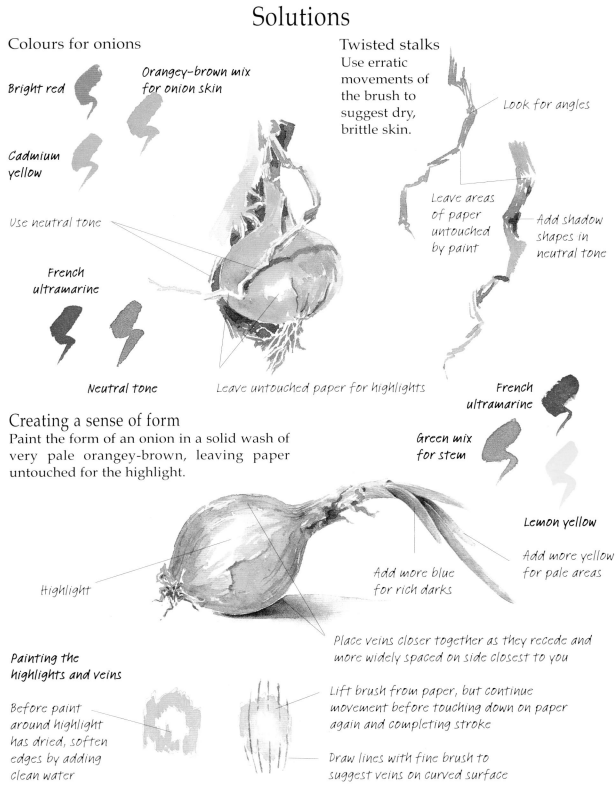

Colours for onions

Bright red

Orangey-brown mix for onion skin

Cadmium yellow

Use neutral tone

French ultramarine

Neutral tone

Leave untouched paper for highlights

Twisted stalks
Use erratic movements of the brush to suggest dry, brittle skin.

Look for angles

Leave areas of paper untouched by paint

Add shadow shapes in neutral tone

French ultramarine

Green mix for stem

Lemon yellow

Add more yellow for pale areas

Creating a sense of form
Paint the form of an onion in a solid wash of very pale orangey-brown, leaving paper untouched for the highlight.

Highlight

Add more blue for rich darks

Place veins closer together as they recede and more widely spaced on side closest to you

Painting the highlights and veins

Before paint around highlight has dried, soften edges by adding clean water

Lift brush from paper, but continue movement before touching down on paper again and completing stroke

Draw lines with fine brush to suggest veins on curved surface

Shapes and Textures: Typical Problems

The surface textures of some root vegetables are very similar to others; this occurs with the similarities between a parsnip and a carrot. In these instances, in order to differentiate between the two other than just with colour, you need to be aware of the feel of the vegetable when holding it. Note the bands that curve around the form – their irregularities, indentations and protrusions – as these are the textures you should endeavour to portray.

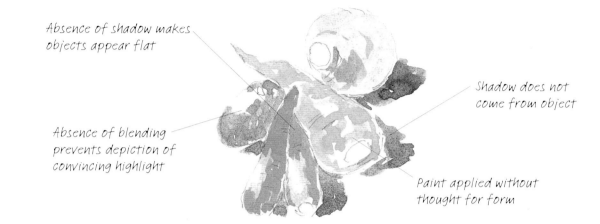

Absence of shadow makes objects appear flat

Shadow does not come from object

Absence of blending prevents depiction of convincing highlight

Paint applied without thought for form

Drawing to observe shape and form

It is important to see and depict the shape and form correctly, as the texture will need to 'follow the form'. Like anything else with drawing, this requires practice.

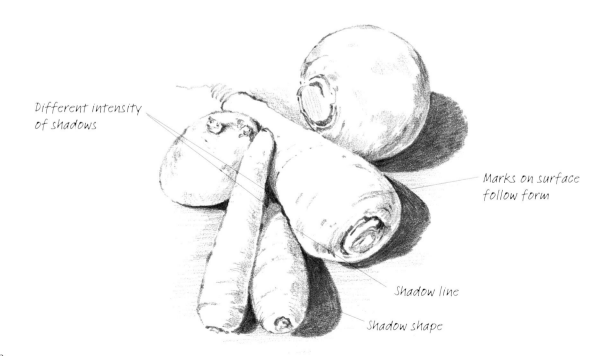

Different intensity of shadows

Marks on surface follow form

Shadow line

Shadow shape

Solutions

Blending textures

Crisp edges, where shadows overlap or cut in behind light forms, provide an interesting contrast to the subtle blending used on the surface of the potato here, and the gentle 'bleeding' required to paint the swede.

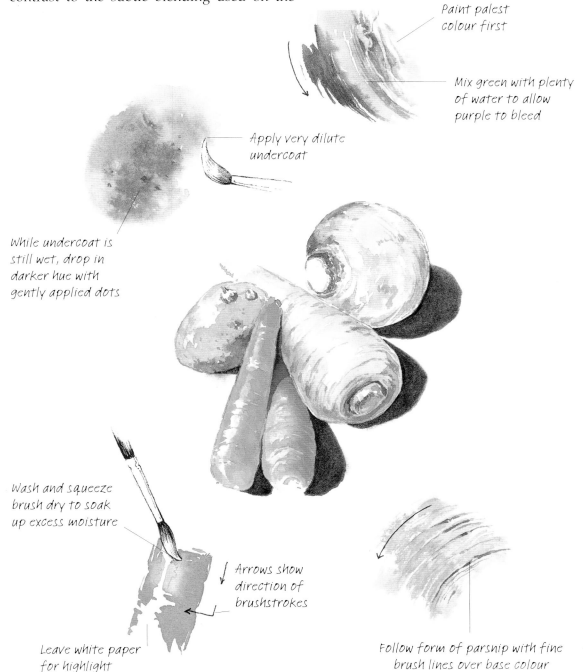

Paint palest colour first

Mix green with plenty of water to allow purple to bleed

Apply very dilute undercoat

While undercoat is still wet, drop in darker hue with gently applied dots

Wash and squeeze brush dry to soak up excess moisture

Arrows show direction of brushstrokes

Leave white paper for highlight

Follow form of parsnip with fine brush lines over base colour

Colour: Typical Problems

The vibrant colours of citrus fruit and contrasting highlights can sometimes prove to be a problem – if the colours are too dull or the highlights are positioned incorrectly, you may end up with a flat, patterned image instead of a three-dimensional impression of form. Where the fruit has been cut and a flat image is required, look closely at the exposed texture, where highlights also play an important part. Keep your colours fresh and unmuddied by limiting the number you use, mixing only one or two together and trying them out on a separate sheet of paper before applying them as translucent washes.

Contrast too marked, and needs subtle blending

Paint applied without sufficient thought for indentations on surface texture

Dark outline unnecessary, as pale pigments easily seen against white paper

No thought given to relationship between each component

Drawing with watercolour pencils

You can remain aware of the colours while working on your drawing by using water- colour pencils, either dry or with water added to solidify the colour.

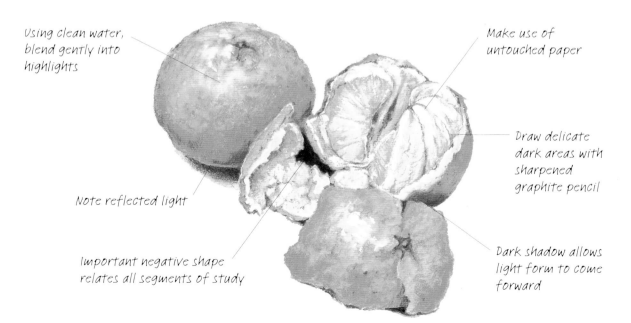

Using clean water, blend gently into highlights

Make use of untouched paper

Draw delicate dark areas with sharpened graphite pencil

Note reflected light

Important negative shape relates all segments of study

Dark shadow allows light form to come forward

Solutions

Single study

Painting a study of a single fruit allows you to concentrate fully on the colour of an individual specimen. The texture on the surface of this lime was achieved by working wet pigment onto a damp surface and allowing it to bleed.

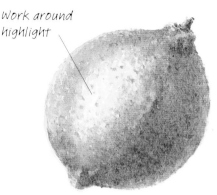

Work around highlight

Citrus group

In a group of similar-shaped and coloured citrus fruits, you need to consider perspective and angles in addition to textures.

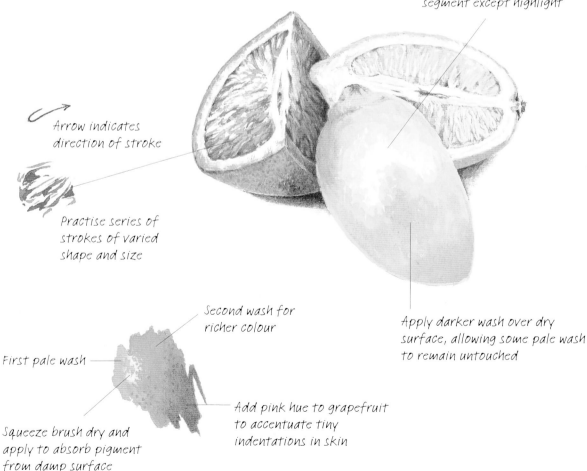

Apply pale wash over whole segment except highlight

Arrow indicates direction of stroke

Practise series of strokes of varied shape and size

Second wash for richer colour

First pale wash

Squeeze brush dry and apply to absorb pigment from damp surface

Add pink hue to grapefruit to accentuate tiny indentations in skin

Apply darker wash over dry surface, allowing some pale wash to remain untouched

Tones in Monochrome: Problems

When an object lacks colour we have an opportunity to become fully aware of tonal variations. Mushrooms, with their interesting forms and rich contrasts of tone, from surface light to gill recesses, and their rich darks encourage you to consider the tonal scale. Beginners often experience problems with a tonal scale and limit their range of tones to such an extent that the subsequent painting appears dull and uninteresting. They also find it difficult to rely solely on tone to create the forms, and resort to unnecessary and uninteresting wirelike outlines to differentiate one form from another.

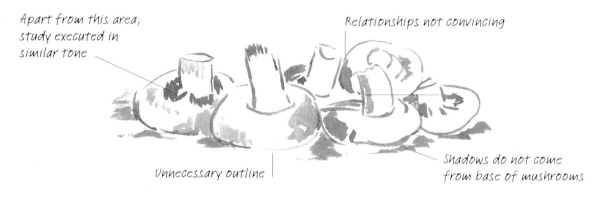

Apart from this area, study executed in similar tone

Relationships not convincing

Unnecessary outline

Shadows do not come from base of mushrooms

Limiting outlines in drawing

Try to use an area of dark tone against a light form without resorting to an outline. Find opportunities to 'lose' these lines.

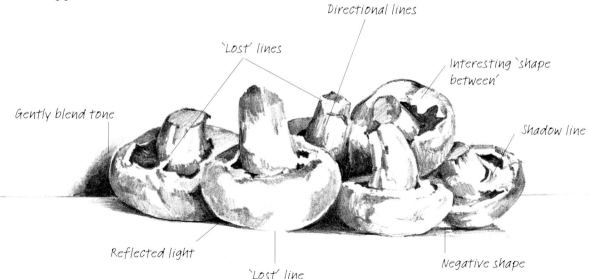

Directional lines

'Lost' lines

Interesting 'shape between'

Gently blend tone

Shadow line

Reflected light

'Lost' line

Negative shape

Solutions

Tonal scale

A good exercise to help understand the tonal scale is to use one colour only – in this example, sepia – diluting the pigment little by little as you paint tonal blocks. In this way you can produce a variety of tones, ranging from intense to weak.

Placing dark behind

Placing a dark tone against a light area produces an exciting tonal contrast. These contrasts are very important within a painting to add interest and bring work to life. Enrich the dark areas (the negative shapes and shadows) to allow untouched white paper (from the other end of the tonal scale) to be used to full advantage and produce strong contrasts.

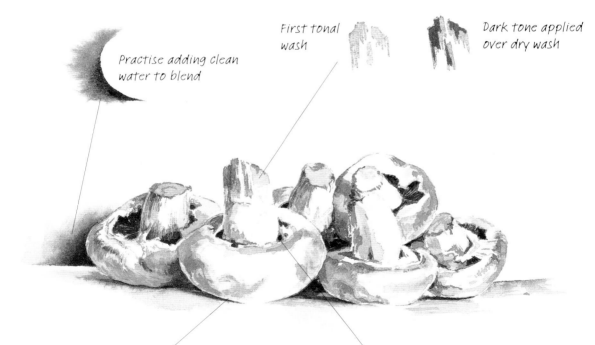

Practise adding clean water to blend

First tonal wash

Dark tone applied over dry wash

For reflected light allow white paper to remain visible at edge of mushroom

Carefully observe and depict small, dark shapes

Animals

Basic Brushstrokes

The following exercises are designed to help you develop an understanding of how to create different textures of animal fur. This page shows the basic brushstrokes in isolation, while the facing page demonstrates how to develop them further in the context of an animal painting.

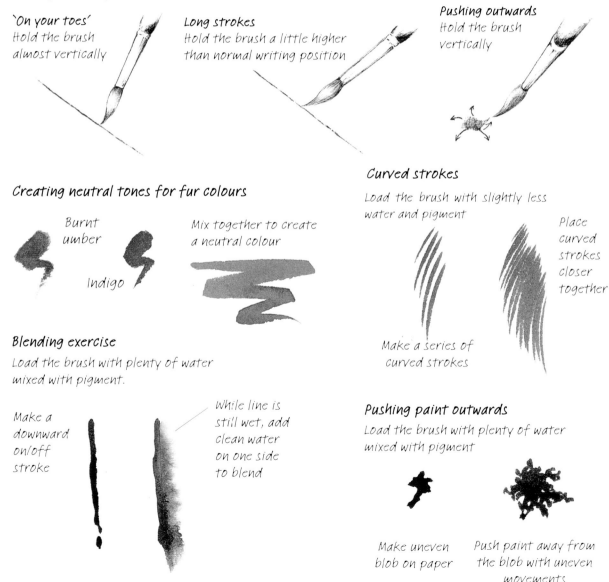

Three painting positions

'On your toes'
Hold the brush almost vertically

Long strokes
Hold the brush a little higher than normal writing position

Pushing outwards
Hold the brush vertically

Creating neutral tones for fur colours

Burnt umber

Indigo

Mix together to create a neutral colour

Curved strokes

Load the brush with slightly less water and pigment

Make a series of curved strokes

Place curved strokes closer together

Blending exercise

Load the brush with plenty of water mixed with pigment.

Make a downward on/off stroke

While line is still wet, add clean water on one side to blend

Pushing paint outwards

Load the brush with plenty of water mixed with pigment

Make uneven blob on paper

Push paint away from the blob with uneven movements

Developing Brushstrokes

These four exercises are developments of the strokes shown opposite. You can very quickly learn how to use them to create the texture of hair or fur. The key to success – which comes with practice – is knowing when to apply clean water to achieve the desired effect.

Glossy, smooth-haired animals

An extension of the blending exercise opposite, this wet-into-wet effect can be used to depict the sheen on an animal's coat.

Make series of joined, angled lines

Where build-up of pigment occurs at angle, add clean water to blend away from line

Leave slight gap of white paper between

'Pull' resulting wash down to run beside lines

Pigment from line spreads across into wash where one touches another

Dense hair or fur

An extension of the curved strokes exercise opposite. Paint initial strokes in one direction, for the undercoat. Once dry, add darker tones to suggest long, dense hair or fur.

Join curved strokes together to form a mass

When dry, add further strokes of a different colour or tone to suggest the texture of hair

Highlights

A variation on the curved strokes, showing how to leave white paper untouched to suggest highlights by 'cutting in' with the darker tones. It is suitable for use on tails and manes.

Pull hair strokes in different directions

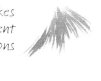

Cut in with dark tone against light

Woolly coats

Push paint outwards, as shown opposite, to develop shapes from a blob – a useful way of depicting woolly-coated animals such as sheep and some breeds of cattle and dogs.

Initial shapes.

Lighten tone by adding water so dark areas suggest shadows

Introducing Ink: Typical Problems

Pen and ink used with watercolour washes is a popular choice, and it is a good idea to practise this combination using a limited palette rather than a wide range of colours. By doing this you are in a position to control the tonal values, as you will not have too many colours to think about at the same time. One animal that possesses neutral or subtle hues naturally is a pig; place the animal in a setting where the same range of colours may be adapted for the background, and enhance the study in a controlled way with the addition of pen and ink.

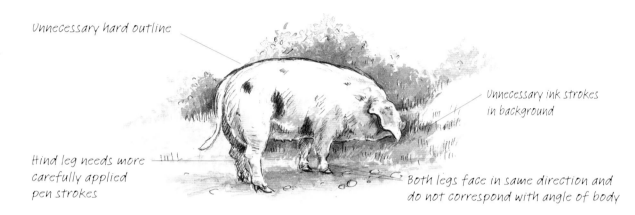

Unnecessary hard outline

Unnecessary ink strokes in background

Hind leg needs more carefully applied pen strokes

Both legs face in same direction and do not correspond with angle of body

From pencil into ink

A preliminary drawing in pencil using guide-lines establishes the scale and position of the subject. Draw the same image alongside in ink, omitting your guidelines and positional marks but being careful to achieve the right proportions. You can use a tracing for this.

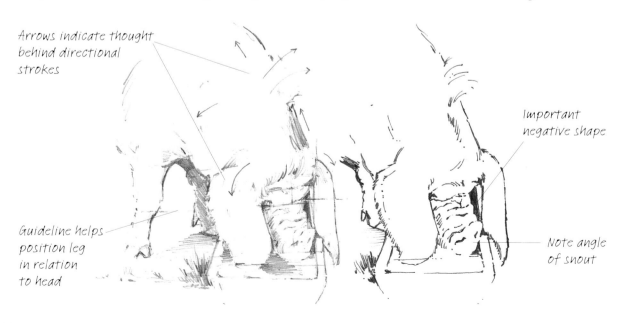

Arrows indicate thought behind directional strokes

Important negative shape

Guideline helps position leg in relation to head

Note angle of snout

Solutions

Working with a limited palette

Before choosing colours for a limited palette, it is a good idea to practise your colour-mixing proportions. By adding a little more of one colour than the other, a monochrome hue can move from the warm range into the cool, and vice versa.

Choice of colours

French ultramarine, Indian red and raw sienna

Ultramarine and raw sienna create a variety of subtle greens

Adding a small amount of Indian red produces a pleasant, neutral hue

Ink over watercolour

Executing your watercolour painting on a rough surfaced paper enables you to drag your pen lightly across the surface and achieve delicate lines that do not overpower the painting.

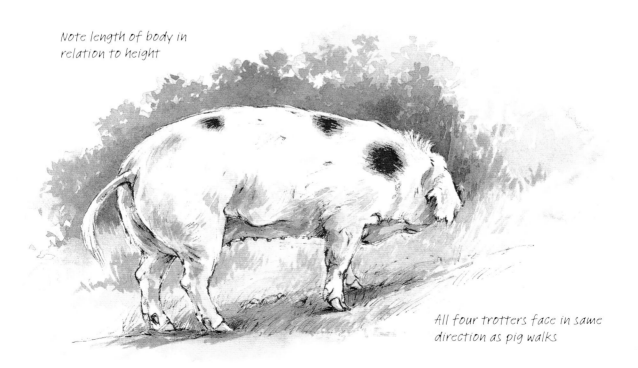

Note length of body in relation to height

All four trotters face in same direction as pig walks

Contexts: Typical Problems

If you do not have the opportunity to observe animals from life, study photographs and watch their movement when they are shown on television. It is very important, when painting animals that spend time outdoors, such as ponies and cattle or sheep, that you include some of the background or context. Very often the contrast between the hair of the animal and the foliage of a landscape, or farm building, can enhance a painting.

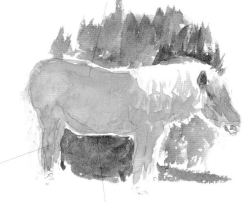

Paint application too dry, preventing creation of subtle tones

Pony and background merge together without differentiation

Area of white paper too wide

Preliminary drawing to establish proportions

Include the background in your preliminary drawing, as this will make it easier to ensure that the scale and proportion are correct within the pony. Also, try to take as much care of shadow and negative shapes as you do over the positives. Think of it as a jigsaw – fit one piece into another until the content of the whole drawing is placed correctly.

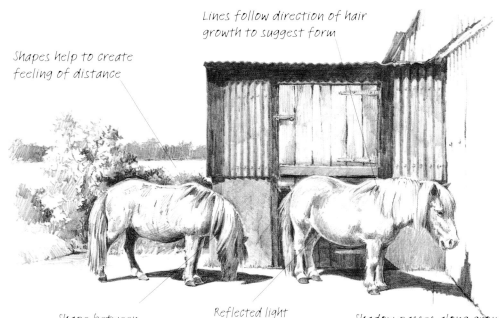

Lines follow direction of hair growth to suggest form

Shapes help to create feeling of distance

Shape between

Reflected light suggests curve of pony's belly

Shadow passes along ground horizontally before climbing vertically up building

Solutions

Placing your subject in context

Clearly differentiate your subject from its
background through careful consideration
of the tones – light against dark, dark next
to light and so on.

Burnt sienna *Raw sienna* *Cobalt* *Cerulean blue*

*Dampen the paper, load your brush
with a mix of cobalt and cerulean blue, and
drop colour onto the surface, leaving some
areas white to suggest clouds*

*Dark washes added to dry initial
wash where shadow shapes
suggest curve of animal's body*

*When sky is dry, paint simple
silhouette shapes to suggest foliage*

*Dark foliage behind
light edge of tail*

*Up-and-down movements
suggest direction of
growth for grass*

*Shadow shape on far leg makes
nearer one stand forward*

Fine detail

This study demonstrates how, by
building darker tones one upon
the other and using delicate,
'directional' brushstrokes, you
can create a three-dimensional
impression.

*Small, but essential, shadow
shapes suggest form*

*Angle of eye neither
straight line nor circle*

*Light tones and areas
of white paper suggest
highlights*

Directional Strokes: Typical Problems

A common problem experienced when painting horned animals is that of how to relate the horn growth to the animal's head. This also applies to the depiction of hooves, whether it be the round hoof of a pony or that of a cloven-footed animal. The most important thing to remember with all of these is the direction involved of both the growth rings on horns and hooves and the hair growth, which itself can cause problems.

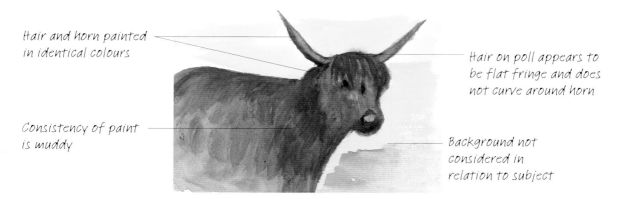

Hair and horn painted in identical colours

Hair on poll appears to be flat fringe and does not curve around horn

Consistency of paint is muddy

Background not considered in relation to subject

Detail studies

Studies of detail may be made in your sketch book. One method is to stand by an animal and look down at the feet to draw them singly, in relation to a small area of ground.

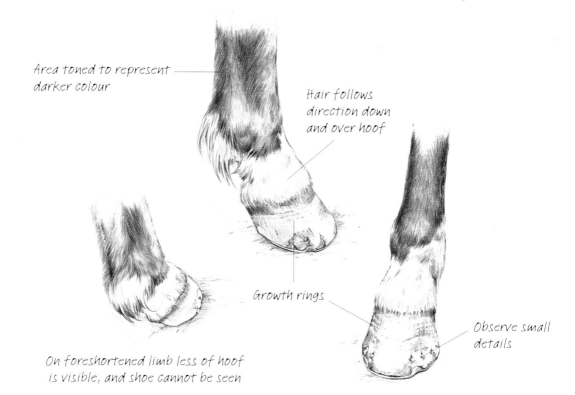

Area toned to represent darker colour

Hair follows direction down and over hoof

Growth rings

Observe small details

On foreshortened limb less of hoof is visible, and shoe cannot be seen

Solutions

Concentrating on hair

For safety reasons, some farm animals are de-horned. In this study there are no horns, so the focus is on hair growth direction over the strong bone structure of the head.

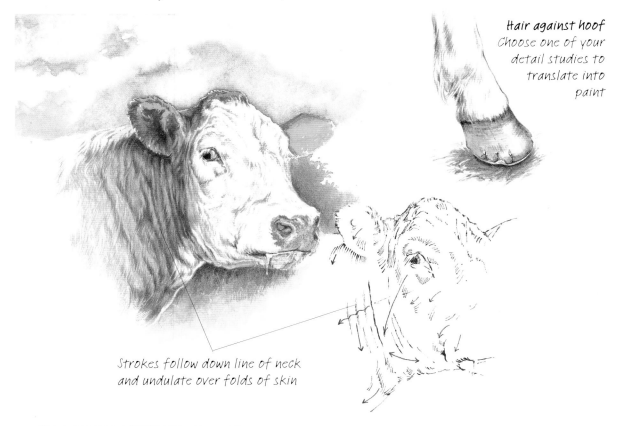

Hair against hoof
Choose one of your detail studies to translate into paint

Strokes follow down line of neck and undulate over folds of skin

Tinted background enhances clarity of image

Use richest tone you can mix in darkest shadow recesses

Disproportionate horn growth

The magnificent curved horns of some varieties of sheep twist and turn, with highlights accentuating the direction.

Working in monochrome enables you to concentrate more on structure of indentations of growth lines

Woolly Textures: Typical Problems

The dense texture of thick wool is a problem for some beginners to depict for a number of reasons. In the drawing and painting below, the problems are clearly visible, both in the drawing of the subject, where the neck has been elongated and the back legs placed unconvincingly, as well as with the texture of the animal's coat.

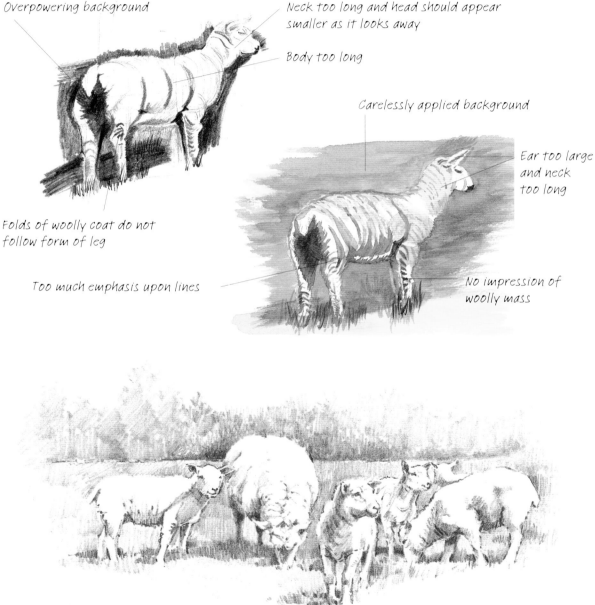

Overpowering background

Neck too long and head should appear smaller as it looks away

Body too long

Carelessly applied background

Ear too large and neck too long

Folds of woolly coat do not follow form of leg

Too much emphasis upon lines

No impression of woolly mass

Grouping subjects
Sheep are usually seen as a flock, so the darks of shadows behind and between their forms allow white paper to play an important role

Solutions

Drawing wool

Animals seen at a distance appear as light shapes against a darker background. For this reason, when drawing wool avoid filling in the image with too much pencil work. Remember that what you leave out is just as important as what is put into a drawing or painting.

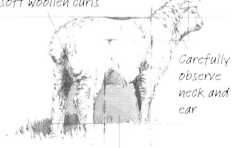

Use rounded marks for soft woollen curls

Carefully observe neck and ear

Negative shape gives correct length of body

Pull green paint down with individual strokes at base to indicate that light grasses are `cutting in´ in front of darker grass

Painting exercise
Transfer the image onto watercolour paper with gentle pressure on your pencil strokes, then place a watery wash of olive green around the drawing

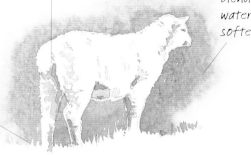

Use neutral hue to suggest texture of wool and shadow areas

Blend in clean water to soften edges

Building up the washes

This little study was painted in stages. After the drawing had been transferred lightly onto watercolour paper a wash of green was painted around the subjects to represent the grass and distant bushes. Care was taken to leave areas of white paper to suggest sunlight upon the sheep, and the shadow sides were painted in textured washes.

Olive green Cobalt blue Raw umber Magenta

Retain light edge

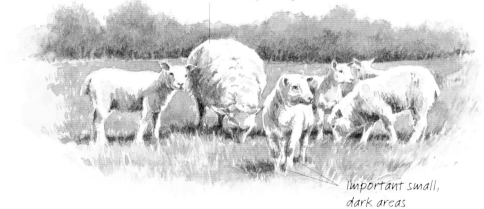

Important small, dark areas

95

Still Lifes in the Landscape

Basic Brushstrokes

These exercises are designed to help you understand brush movements and pressures related to the methods used in this theme. For instance, superimposing lines to suggest grain on a wooden surface and painting the grille of an old car incorporate very similar techniques; in the same way, curved brushstrokes of uneven pressure help to give the impression of tread on tyres and overlapping planks on a boat. Sideways sweeps of the brush depict flat panels, sheets of glass and so on, and you can adapt them to indicate curved panels with dark recesses behind.

Colours for neutral

Hookers green *Cool red*

A mix of these colours provides a useful neutral hue

Superimposing grain
For this exercise, hold the brush sideways against the paper in a horizontal position.

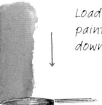

Load brush with plenty of paint, sweep wide stroke down and allow to dry

Draw lines over tonal block with similar pointed brush

Curved lines
A normal writing position is the best one to adopt for this exercise.

Draw series of curved lines with No. 6 or 8 pointed brush

Use smaller brush to draw series of fine lines

Sideways sweeping strokes
For this exercise, hold the brush at less of an angle to the paper than for the previous one.

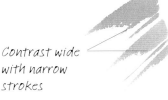

With swift movements, make series of diagonal, sweeping strokes

Contrast wide with narrow strokes

Curved metal surfaces
To suggest highlight areas, enhance controlled sweeps of the brush by adding fine lines.

Cut in closely with dark tones, leaving very fine white edges between tones

Developing Brushstrokes

The exercises here are developments of the strokes shown opposite. They demonstrate varied pressure on the brush, angles of application and superimposed marks, and are designed to help you become aware of the importance of following the form of an object in order to create a three-dimensional impression of your subject.

Wood grain

This is an extension of the superimposing grain exercise opposite. You can also use it to suggest the grille on a car, but the strokes will need to be straighter.

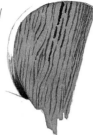

Paint grain using small brush, and include curved and textured lines

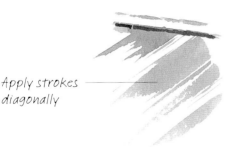

Strokes depict shadow shapes on grille of car

Curved strokes following form

Overlapping planks on boat and tyre treads follow the form of the object. This is an extension of the curved lines exercise opposite.

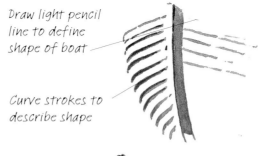

Draw light pencil line to define shape of boat

Curve strokes to describe shape

Stroke with more texture, achieved by on/off pressure, suggests tyre tread

Sweeping strokes

Use sideways sweeping strokes to suggest a flat metal panel on the side of a trailer, for example, or glass in the windows of a vehicle or a boat.

Apply strokes diagonally

Strokes for curved metal surfaces

These exercises are extensions of the sweeping strokes shown opposite. When applied swiftly, or at varying angles and of different lengths, you can quickly indicate curved metal areas like those seen on the bonnet of a motor vehicle.

Cut in with dark shadow shapes to suggest engine in shadow

Garden Benches: Typical Problems

It is only by making comparisons with certain subjects/objects that we can develop a deeper understanding of methods. For instance, the fencing in a landscape is made up of both vertical and horizontal posts and rails – by observing the elongated shapes between these you can achieve scale, proportion and perspective accurately.

When drawing a bench, beginners often experience problems with perspective and proportions when they consider only the positive shapes, as seen below.

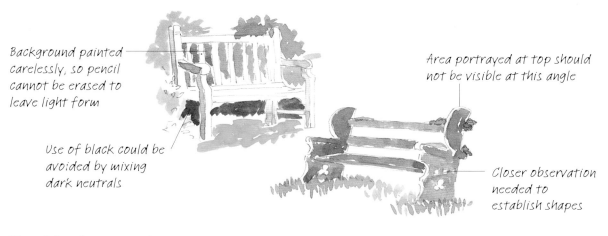

Background painted carelessly, so pencil cannot be erased to leave light form

Use of black could be avoided by mixing dark neutrals

Area portrayed at top should not be visible at this angle

Closer observation needed to establish shapes

Sketchbook composites

The freedom of using a sketchbook allows you to place objects of varying scale, seen at different angles of perspective, in close proximity to each other. You can draw the object against a relevant background, or portray it simply as the object. In both cases it is most important to relate it to the ground – in other words, anchor it.

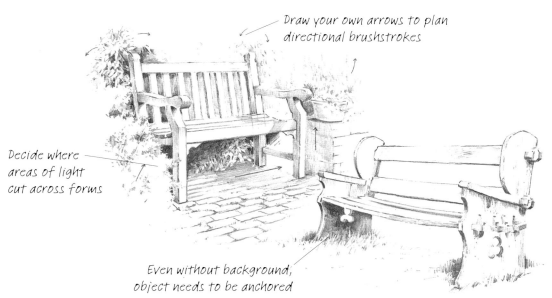

Draw your own arrows to plan directional brushstrokes

Decide where areas of light cut across forms

Even without background, object needs to be anchored

Solutions

Learning from comparisons

An important comparison is that of the presented with the background playing an integral part, and a study where no background is included. The upper painting demonstrates how crucial it is to consider the background and paint around the form when you decide to paint your subject in a setting. The lower bench is made of darker wood and can be presented as a study without background.

Both studies demonstrate how observing and drawing the negative shapes between the vertical and horizontal slats leads to accurate placing of the positive shapes.

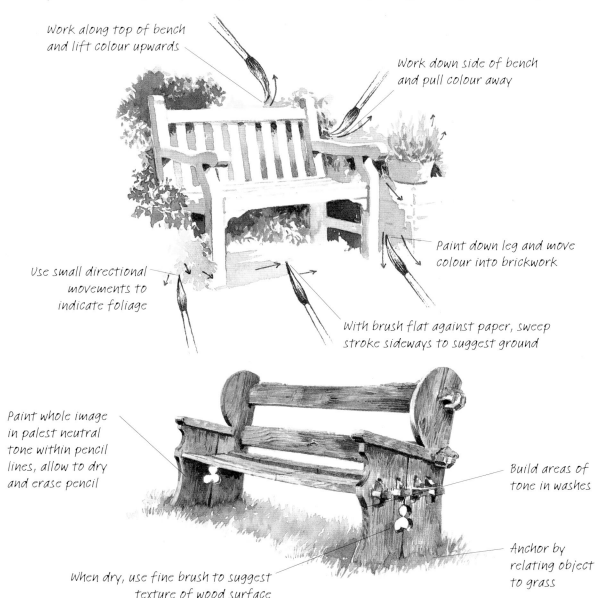

Work along top of bench and lift colour upwards

Work down side of bench and pull colour away

Use small directional movements to indicate foliage

Paint down leg and move colour into brickwork

With brush flat against paper, sweep stroke sideways to suggest ground

Paint whole image in palest neutral tone within pencil lines, allow to dry and erase pencil

Build areas of tone in washes

Anchor by relating object to grass

When dry, use fine brush to suggest texture of wood surface

Half-hidden Objects: Typical Problems

The painting below suffers from the typical beginners' difficulty of knowing how to mix colours effectively, leading to the unnatural hues on display. It also shows how a lack of understanding and knowledge regarding the use of negative shapes leads to a flat and patterned effect rather than the desired three-dimensional impression.

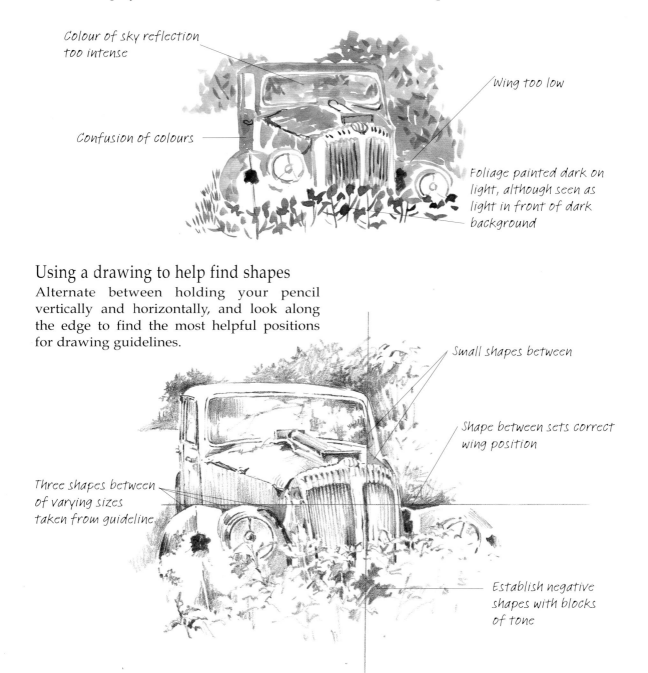

Colour of sky reflection too intense

Wing too low

Confusion of colours

Foliage painted dark on light, although seen as light in front of dark background

Using a drawing to help find shapes

Alternate between holding your pencil vertically and horizontally, and look along the edge to find the most helpful positions for drawing guidelines.

Small shapes between

Shape between sets correct wing position

Three shapes between of varying sizes taken from guideline

Establish negative shapes with blocks of tone

Solutions

Using a few colours effectively

It is a challenge to work with a limited palette of three colours that may not be a natural choice for the subject, as it encourages you to consider the proportions of pigment in your colour mixes. In addition, in order to use dark negative shapes to full advantage (so that they provide rich contrasts to light areas) you need to experiment with colour intensity. The nature of the pigments here means that you are likely to discover some separation of colour in your mixes. This provides added interest and can create some exciting effects.

Colour mixing

Practise mixing these three colours in different proportions until you have a variety of hues in your palette wells.

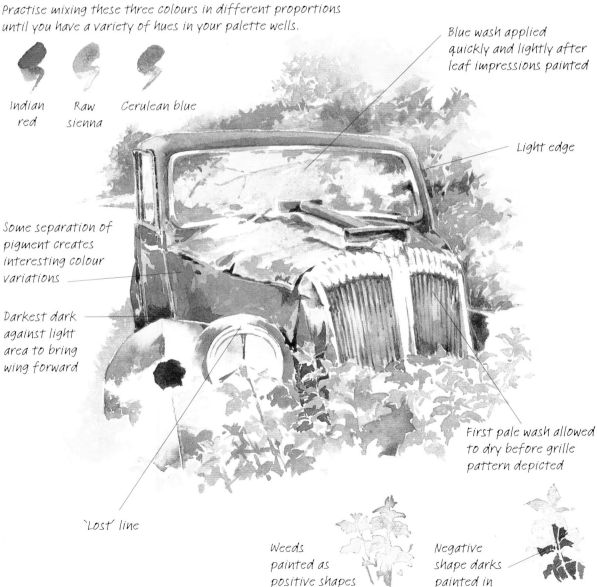

Indian red

Raw sienna

Cerulean blue

Blue wash applied quickly and lightly after leaf impressions painted

Light edge

Some separation of pigment creates interesting colour variations

Darkest dark against light area to bring wing forward

First pale wash allowed to dry before grille pattern depicted

'Lost' line

Weeds painted as positive shapes

Negative shape darks painted in

Vehicles with Rounded Shapes: Typical Problems

An old farm machine such as a tractor abandoned in a field can provide the artist with interesting subject matter, as it offers a variety of colour (against the greens), the texture of damaged metal, tonal contrasts (engine in shadow) and various curves and contours. Beginners who are unaware of a guideline method of drawing may experience problems with perspective (as shown below) as well as their interpretation of the subject in paint.

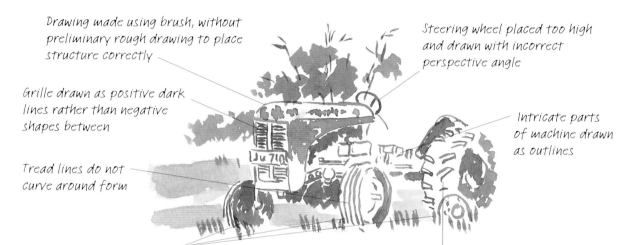

Drawing made using brush, without preliminary rough drawing to place structure correctly

Steering wheel placed too high and drawn with incorrect perspective angle

Grille drawn as positive dark lines rather than negative shapes between

Intricate parts of machine drawn as outlines

Tread lines do not curve around form

Visible wheels placed at same level with no thought for perspective

Outlines rather than blocks of tone

Drawing correct contours

There are many curves to be found in this subject – the steering wheel and below the bonnet and wheel arch, as well as the tyres, where the front wheels are angled slightly. Practise finding these contours on a preliminary reference drawing.

Observe negative shapes between wheel arches

Series of curves needs close observation

Solutions

Building washes

Although strong contrasts are an important part of this study, they are not painted dark initially. Instead, pale colours are applied to the lightly drawn pencil work and are allowed to dry before the pencil is erased and a gradual building of washes is undertaken.

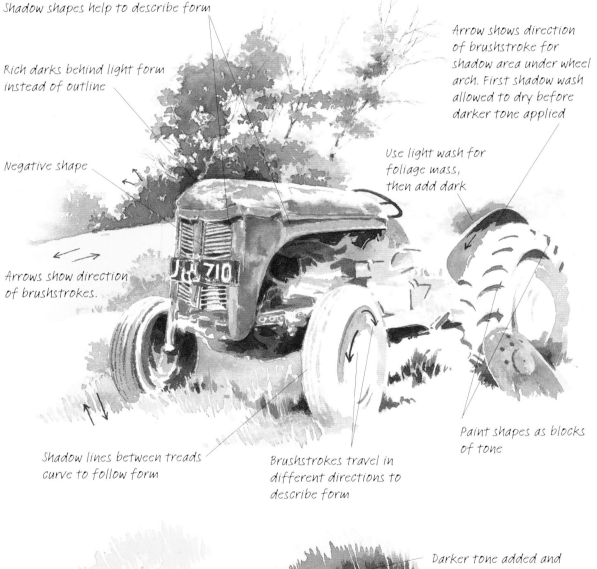

Shadow shapes help to describe form

Rich darks behind light form instead of outline

Negative shape

Arrows show direction of brushstrokes.

Arrow shows direction of brushstroke for shadow area under wheel arch. First shadow wash allowed to dry before darker tone applied

Use light wash for foliage mass, then add dark

Paint shapes as blocks of tone

Shadow lines between treads curve to follow form

Brushstrokes travel in different directions to describe form

Darker tone added and other colours and tones dropped in while still wet

Grass mass painted in light tone and allowed to dry

Straight-sided Vehicle: Typical Problems

An old trailer tilted at an angle in a field offers the opportunity to make a perspective study using guidelines to establish the correct angle. In the painting below, problems arose with the treatment of side panels and tyres as well as with the perspective and the angles in the composition. It may be that the subject itself is complex and could be simplified (without losing its identity) to provide a valuable exercise.

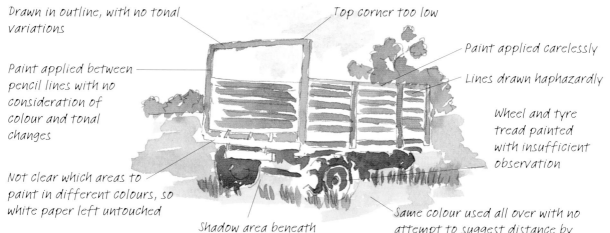

Drawn in outline, with no tonal variations

Paint applied between pencil lines with no consideration of colour and tonal changes

Not clear which areas to paint in different colours, so white paper left untouched

Top corner too low

Paint applied carelessly

Lines drawn haphazardly

Wheel and tyre tread painted with insufficient observation

Shadow area beneath trailer not painted in

Same colour used all over with no attempt to suggest distance by varying tones

Drawing what you see

This drawing shows exactly how the trailer appeared – with corrugated sides and heavy tyre treads. A sense of recession is suggested by the angles of the top and base lines.

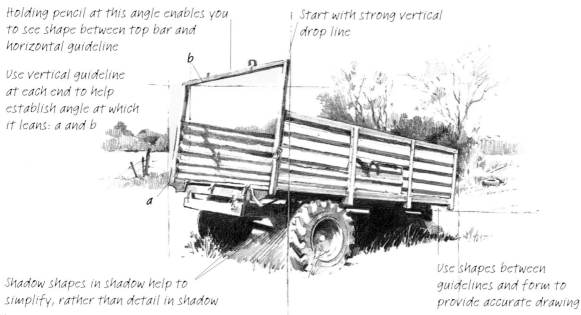

Holding pencil at this angle enables you to see shape between top bar and horizontal guideline

Use vertical guideline at each end to help establish angle at which it leans: a and b

Start with strong vertical drop line

b

a

Shadow shapes in shadow help to simplify, rather than detail in shadow

Use shapes between guidelines and form to provide accurate drawing

Solutions

Finding the basic shape

A flat surface has been substituted for the corrugated sides, and the tyres are now smooth. A couple of sacks were added to provide interest within the interior.

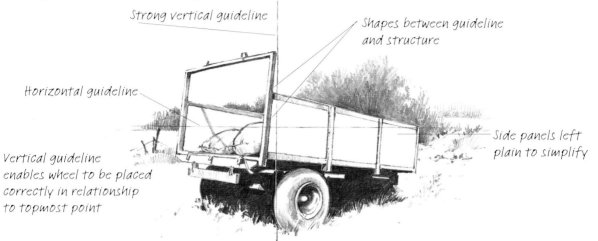

Strong vertical guideline

Shapes between guideline and structure

Horizontal guideline

Side panels left plain to simplify

Vertical guideline enables wheel to be placed correctly in relationship to topmost point

Painting simple shapes

For some simple shapes, it is useful to practise swift brushstrokes. For others, such as the tyres, just suggest the tread rather than going into detail. To create a little incidental texture on the plain panels, Saunders Waterford 300gsm (140lb) Rough paper was used.

Simplify foliage by following light green with darker overlay

Quick directional strokes in neutral colour suggest solid panels

Painting dark behind light edge of the trailer means no outline needed

Dark shadow beneath trailer painted in light tones and allowed to dry before next application

Arrow shows direction of brushstrokes to follow form

Uneven downward dark tones allow white paper to remain before green added in front

Boats on Sand: Typical Problems

When the background is stronger than the objects it surrounds, beginners sometimes treat it in a way that overpowers foreground subjects, as can be seen in the painting below – the band of dark concrete behind these boats, plus a tree-covered bank above, vie for attention with the boats in the foreground. A simple solution to this problem is to choose a tinted paper to unify the study by blending or using the natural tint of the surface.

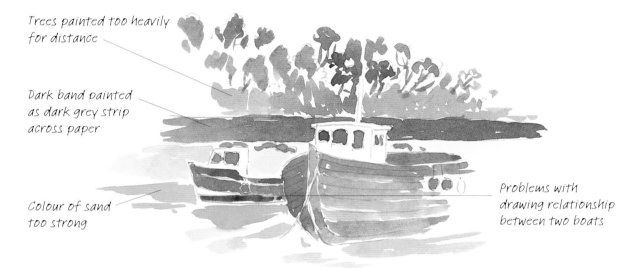

Trees painted too heavily
for distance

Dark band painted
as dark grey strip
across paper

Colour of sand
too strong

Problems with
drawing relationship
between two boats

Establishing a relationship between the main subjects
Use a drawing to make sure that the subjects in your composition relate convincingly both to each other and to the surroundings.

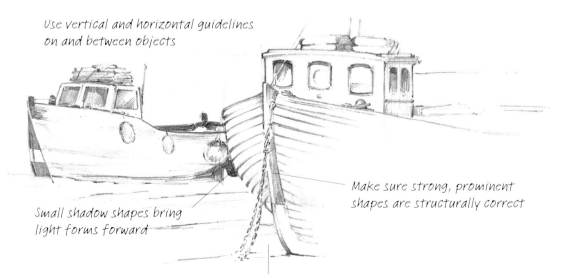

Use vertical and horizontal guidelines
on and between objects

Small shadow shapes bring
light forms forward

Make sure strong, prominent
shapes are structurally correct

Shape between bow of boat, surface of sand and chain is important shape between

Solutions

Blending on tinted paper

Cream-tinted Bockingford 300gsm (140lb) watercolour paper was chosen for this study, where the predominating colour is that of sand. The tint works well under a blended green to suggest a tree-clad hillside in the background, and allows a little Chinese white to be added to the painted surfaces of the boats in order to lift these areas out of the middle ground.

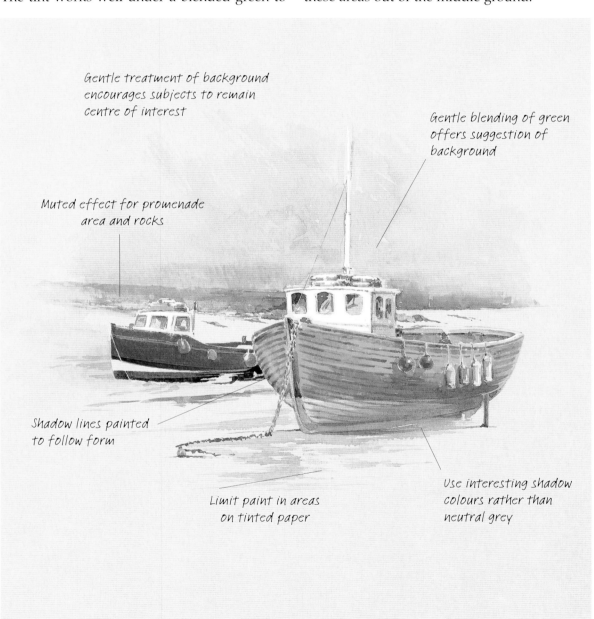

Gentle treatment of background encourages subjects to remain centre of interest

Gentle blending of green offers suggestion of background

Muted effect for promenade area and rocks

Shadow lines painted to follow form

Limit paint in areas on tinted paper

Use interesting shadow colours rather than neutral grey

Still-Life Materials

Basic Brushstrokes

These exercises are designed to help you understand how to depict highlights on smooth surfaces such as copper, porcelain and glass. There is also an exercise to help you paint folds within fabric, which is often used as a background in still-life paintings. The basic brushstrokes are shown below, while on the opposite page they are incorporated within some of the still-life objects that are covered in this theme.

Choosing colours

Once you start to observe and paint man-made objects for still-life pictures, you need to consider an alternative set of colours to the natural ones found outdoors, in nature.

Colour for green glass

Colour for copper

Yellow glaze for reflections and highlights

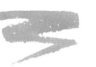

Windsor & Newton Quinacridone yellow for glaze

Blue mixture for fabric

Fine lines for crisp edges

A natural painting/writing position was used for these exercises. These lines are basic on/off pressure strokes, as used in the other brush-stroke exercises (on pages 40, 50, 62, 74 and 86).

For very delicate, fine lines, use a No. 0 pure sable brush

Using a larger No. 8 pointed synthetic brush, apply gentle pressure for fine lines and increase pressure for wider tapering strokes

For delicate lines with more weight, a No. 2 pure Kolinsky sable brush is ideal

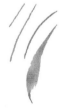

Curves and squiggles

Mirrored images, especially those found on curved or uneven surfaces such as copper containers, require a feeling of movement in the brushstrokes.

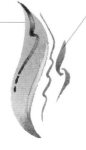

Paint applied over dry image

Create squiggles and curved strokes that suggest movement, similar to those used to interpret water

Cutting in and contours

Curve the edges of tonal blocks and incorporate fine lines – either as dark lines on light paper or as a white line created by toning either side.

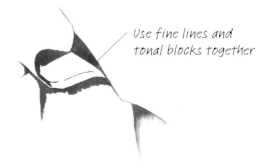

Use fine lines and tonal blocks together

Developing Brushstrokes

These four developments of the strokes shown opposite incorporate crisp edges (as seen on glass, copper and mirrored images in other smooth surfaces), strong contrasts (useful in all subjects), and gentle blending (shown to advantage in fabric folds and highlights). By practising these exercises you will learn how to retain white paper when indicating highlights by painting around these areas, and how to subsequently blend away from the highlighted areas and dark contrasted shadow shapes.

Bottles and other glass object

This is an extension of the fine line exercises shown opposite. These two exercises show how to work around the area to be high-lighted, using rich colour.

Use a variety of curved strokes, straight lines and squiggle.

Small shapes, dots and dashes are useful

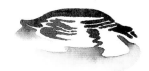

Introduce other colours by gentle blending

Mirrored images on copper

This is an extension of the curves and squiggles exercise opposite. First, paint the shapes of the reflections you see within the surface, allow them to dry, then swiftly sweep the yellow glaze over the area where no white paper is to remain.

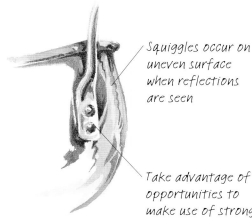

Squiggles occur on uneven surface when reflections are seen

Take advantage of opportunities to make use of strong contrasts

Fabric folds

This is an extension of the cutting in and contours exercise on the opposite page. Note the crisp light edges brought forward by the dark tones that suggest areas of recess.

Paint dark area, allow to dry, then paint darker still in corners

Pull dark pigment away from dark of recess, blending with clean water if necessary

Glass: Typical Problems

Although glass objects may be uniform in colour, remember that because of the way light shines through them, the density of colour will vary. Highlights where the light bounces off the surface are also critical in making the object appear three-dimensional. Objects reflected in glass are distorted in shape, and clear, colourless, glass often picks up colours from objects nearby. Accurate drawing of a bottle or glass can often be a problem, even before you start to paint. Once you have mastered this, your observation will still have to be precise in order to position the reflections accurately, especially when another object is placed alongside.

In the study to the right there is no beneficial relationship between the bottle and glass. The bottle has not been given a translucent appearance because too much strong colour has been used in a careless manner, and as a flat wash over a pale wash. There is only one highlight area, when many more could have been observed.

Top of bottle too heavy

Glass appears to be floating in space – placing it in relationship to bottle would anchor it

This area is starting to work well, but surrounding areas lose credibility

Drawing subjects closer
Place the glass in front of the bottle and see how perspective affects scale. The top of the glass and bottle are slightly above eye level and curve in the opposite direction to their bases.

Series of guidelines produces small shapes that help to position objects

Label of bottle produces pattern within stem of glass

Use guidelines to help achieve correct proportions

Dark base of bottle is seen through glass as abstract shape

Solutions

Separating objects to show distortions

If you pull the glass a little away from the bottle, you can see how the distortions become more apparent – as if the colourless glass is absorbing colour to enhance its own image.

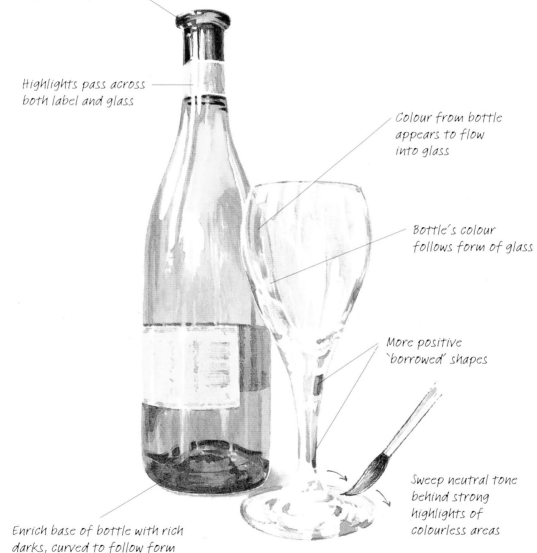

Look closely at reflections in busy area to enhance your interpretation

Highlights pass across both label and glass

Colour from bottle appears to flow into glass

Bottle's colour follows form of glass

More positive 'borrowed' shapes

Enrich base of bottle with rich darks, curved to follow form

Sweep neutral tone behind strong highlights of colourless areas

Ceramics: Typical Problems

Objects made of fine china lend themselves to being painted in a very delicate style, especially if the porcelain is white. In this case the existence of a pattern on the surface adds interest, and because it follows the form of the surface, it can help to achieve a three-dimensional impression. In the study below right the artist has painted the pattern to follow the form of the vase, but in the left-hand painting it appears flat and disjointed.

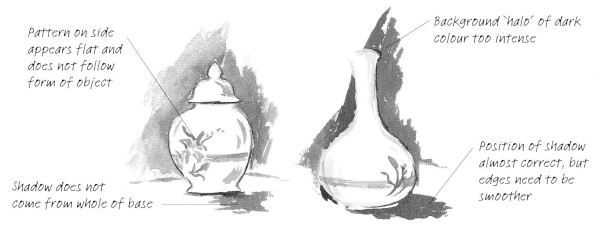

Pattern on side appears flat and does not follow form of object

Shadow does not come from whole of base

Background 'halo' of dark colour too intense

Position of shadow almost correct, but edges need to be smoother

Drawing upon knowledge

Even if you eventually want to paint each object individually, placing them as a group in relation to each other helps you gain knowledge of their shape and form.

Look at the objects from a different angle, and separate the object itself if possible (in this case a lid was removed) in order to draw and understand ellipses.

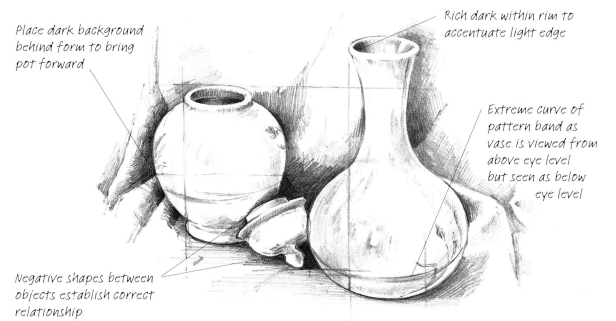

Place dark background behind form to bring pot forward

Rich dark within rim to accentuate light edge

Extreme curve of pattern band as vase is viewed from above eye level but seen as below eye level

Negative shapes between objects establish correct relationship

Solutions

Depicting white

Most depictions of porcelain rely on the use of white paper as the objects themselves are white. With a shadow side, a neutral colour is used, both to work around the areas to be left white and to accentuate any highlights on the surface of the porcelain.

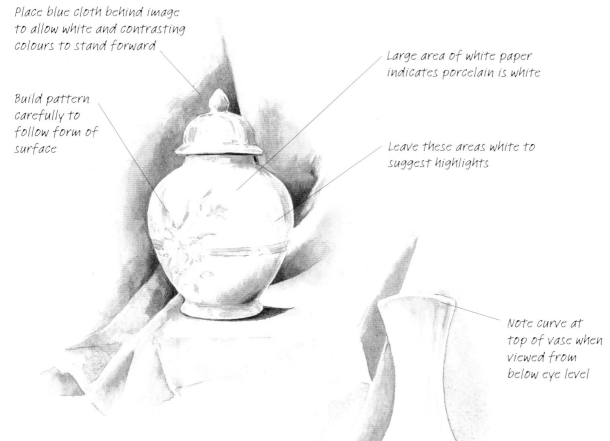

Place blue cloth behind image to allow white and contrasting colours to stand forward

Large area of white paper indicates porcelain is white

Build pattern carefully to follow form of surface

Leave these areas white to suggest highlights

Note curve at top of vase when viewed from below eye level

Building washes

Here, delicate washes are overlaid on the white vase to indicate a shadow at its base. This example shows how the shadow shapes are established before the colour and tone are built up.

'Lost' line

Metals: Typical Problems

Some metals reflect their surroundings in the same way as water and a mirrored image. A curved copper surface reflects and distorts the contents of a room within its area. It can, therefore, appear to be a very busy image, showing the colours of surrounding objects to a limited extent, which are always influenced by the copper colour. In the painting below you can see some typical drawing problems regarding scale, proportion and perspective, as well as the problem of how to deal with distorted mirror images.

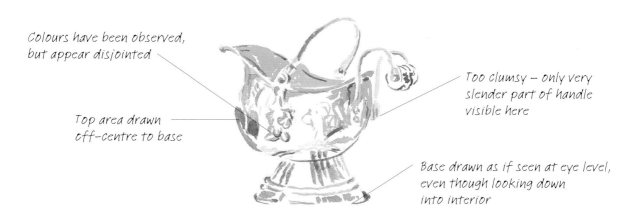

Colours have been observed, but appear disjointed

Top area drawn off-centre to base

Too clumsy – only very slender part of handle visible here

Base drawn as if seen at eye level, even though looking down into interior

Drawing from a different viewpoint

To help you become familiar with this, or any other subject, draw it from a different angle.

Note the ellipse that appears as you look down into the receptacle, and also at the base.

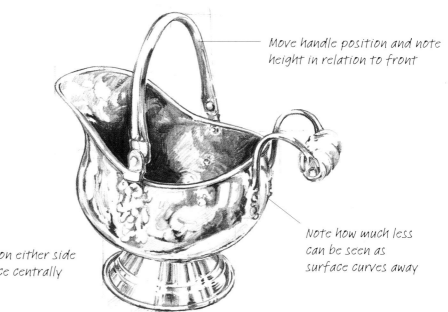

Move handle position and note height in relation to front

Guidelines on either side help to place centrally

Note how much less can be seen as surface curves away

Solutions

Colours and contours

Before you start painting, select a limited range of colours to suit the subject – in this case copper. Remember the importance of leaving white paper for highlights.

You need to have good brush control in order to depict curves and contours, so at the base of the page there is a little exercise demonstration for you to practise sweeping, curved strokes.

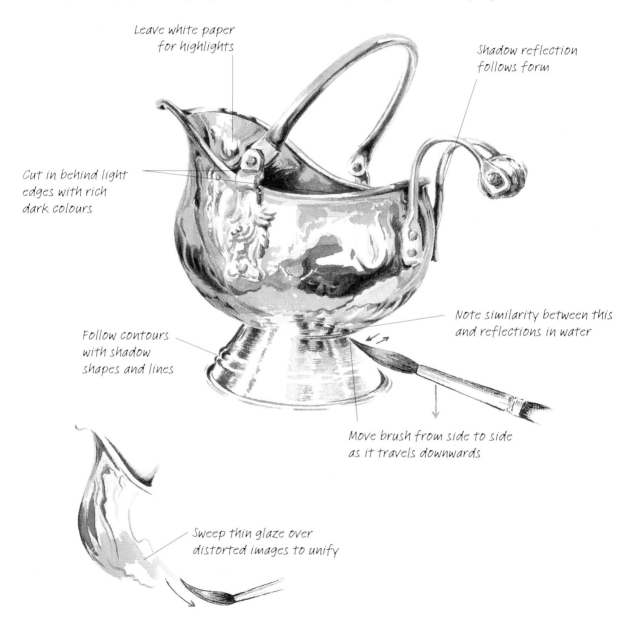

Leave white paper for highlights

Shadow reflection follows form

Cut in behind light edges with rich dark colours

Note similarity between this and reflections in water

Follow contours with shadow shapes and lines

Move brush from side to side as it travels downwards

Sweep thin glaze over distorted images to unify

Fabric: Typical Problems

Fabric is often used as a background for still-life groups, as the folds help you to form a relationship between the objects. Used as a cover, fabric follows the form of the object beneath, for example a cushion cover or an item of clothing being worn. A hung or draped shirt or blouse provides you with an interesting array of folds, as well as other related components like pockets, buttons and the attached sleeves. For many beginners it is these folds that cause problems, as in the study to the right.

Drawing to describe folds

Using a very sharp pencil, gently tone layer upon layer to build the darks. Follow the form, curving around contours and cutting in behind light areas to suggest undulations of folded material. Leave the white paper for highlights.

Random lines are superficial and do not give impression of recess

Same blue used throughout, more intense within folds, rather than effective shadow colour

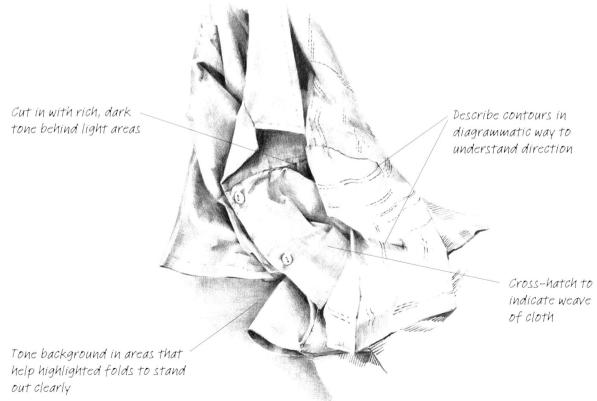

Cut in with rich, dark tone behind light areas

Describe contours in diagrammatic way to understand direction

Cross-hatch to indicate weave of cloth

Tone background in areas that help highlighted folds to stand out clearly

Solutions

The 'ins and outs' of folded material

For this exercise, imagine an insect wandering in and out of the folds of a garment – when the insect is at the highest level, it is probably standing on a highlighted area.

Leave these highest areas as white paper and apply your tones, in varying degrees, behind it, working from the lightest to the very darkest tones.

Small shadow shapes add interest to shadow line

Hint of red incorporated with blue within shadow tone areas

Untouched white paper

Where rich dark suggests shadow recess, add clean water carefully at edge and blend with swift brushstrokes

Lower part of garment shows first pale colour washes

Buildings

Basic Brushstrokes

The exercises on this page are designed to help you become aware of the importance of the varied and directional brushstrokes required to depict the textured effects used when painting buildings. On the opposite page you can see how they may be developed within this context.

Burnt umber · French ultramarine

Mixed to produce brown hue.

Blended with water for pale tones.

Angled, varied pressure strokes
Use the normal painting position for these strokes. Note the effect that can be achieved by just varying the pressure on Rough-textured paper.

Lift brush from paper occasionally

Repeat strokes closer together with fine brush

Partial drybrush effect
This is suitable as a base texture for many surfaces. Hold the brush horizontal to the paper, letting the whole length of hairs remain in contact throughout the stroke. Note how the Rough surface of the paper robs the brush swiftly of its pigment.

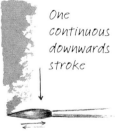

One continuous downwards stroke

Block and lift strokes
Hold the brush a little more vertically for this solid one-stroke impression. Place another stroke immediately alongside.

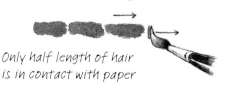

Only half length of hair is in contact with paper

Narrow lines, wide bands
Use the normal painting position for this variety of stroke, where the aim is to depict gentle undulations.

Make undulating, wide bands with single block stroke, or paint in with smaller strokes

Wide shape, narrow shape
Use the normal painting position for the first part of the stroke, angled towards the paper to complete the stroke as you pull down or along. Use the tip of the brush.

Developing Brushstrokes

The five exercises on this page are developments of those shown opposite. Four of the exercises are influenced by the Rough-textured Saunders Waterford paper, which was chosen in order to enhance these effects.

It is important that you discover how the paper you choose to work on may affect the impressions you create – you can do this by experimenting before you start to paint your pictures.

Varied pressure strokes

This extension of the exercise shown opposite is designed to suggest a tiled roof.

Short, slightly angled, downward lines join disjointed lines

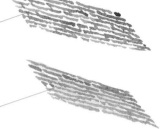

When dry, wash different colour across whole surface

One-block stroke

An extension of the block and lift stroke shown opposite, this exercise shows you how the blotting-off method (see p. 27) works on a brick or stone image.

Basic (wet) stroke

Blot off and drop in more pigment before image has dried

Narrow lines and wide bands

This exercise shows you how the one opposite can be used for a mirrored image on glass-fronted buildings. This image is best suited to a smooth-surfaced paper, but, as you can see here, it can also be painted onto Rough texture and still achieve a smooth effect.

Wide shape, narrow line stroke

An extension of the wide shape, narrow shape stroke, this shows how the two may be joined. Use this stroke to depict smooth stone walls – remember to enhance the negative 'shapes between' with a rich, dark hue to suggest recesses.

Drybrush overlay

To depict textured surfaces of walls or timber, apply a further stroke of the brush over the initial partial dry-brush stroke shown on the opposite page.

Basic image

Blot off/drop in for shadow textures

Timber: Typical Problems

A timber building in a neutral hue can offer a pleasing contrast to its surroundings. However, many beginners, in their quest for colour, fail to take advantage of the subtle neutrals and paint a variety of browns, as seen in the picture below. This painting has lost harmony, and the numerous lines, drawn without regard for tone and texture, are overpowering. Do not be afraid to take advantage of a monochrome effect for certain subjects – greens in the background can almost be a monochrome study in themselves – as there are occasions when understatement has its own charm.

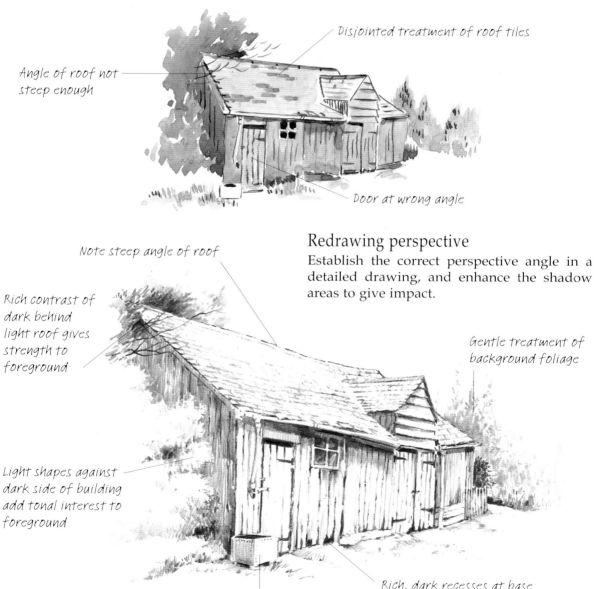

Disjointed treatment of roof tiles

Angle of roof not steep enough

Door at wrong angle

Note steep angle of roof

Redrawing perspective

Establish the correct perspective angle in a detailed drawing, and enhance the shadow areas to give impact.

Rich contrast of dark behind light roof gives strength to foreground

Gentle treatment of background foliage

Light shapes against dark side of building add tonal interest to foreground

Small objects drawn carefully

Rich, dark recesses at base require crisp edges

Solutions

Working in monochrome

This painting is limited to two almost mono-chrome areas – the neutrals of the timber building and the greens of the foliage in the foreground and background.

This monochromatic approach enables you to concentrate upon the importance of tonal contrasts rather than hue. The only additional colour is in the blue sky.

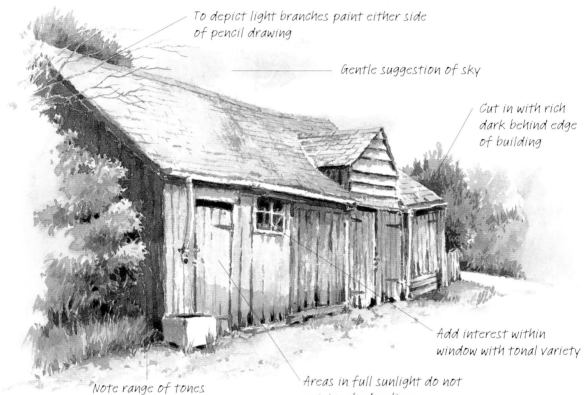

To depict light branches paint either side of pencil drawing

Gentle suggestion of sky

Cut in with rich dark behind edge of building

Add interest within window with tonal variety

Areas in full sunlight do not receive shadow lines

Note range of tones within shadow areas

Ways to create textures on timber

Here are a couple of exercises to help you discover ways of creating a textured surface effect.

Rough texture with drybrush technique

Drag paint across surface in direction of wooden planks

Draw in dark shadow shapes between planks with fine point of brush and stronger pigment

Describing darks

Establish position of planks

Apply slightly darker tone than first wash using drybrush technique

Paint in dark shadow shapes and shadow lines

Corrugated Iron and Stone: Typical Problems

Old or derelict buildings may be made up of many different materials, and can thus supply the artist with numerous textured surfaces to depict in paint. On this neglected building an old corrugated iron roof over stonework contrasts with timber doors and peeling hard-board panels, and is softened by the foliage. With so much to observe, it is not surprising that some beginners simplify everything to such an extent that the essence of the building and its setting are lost in a mass of conflicting colours and patterns.

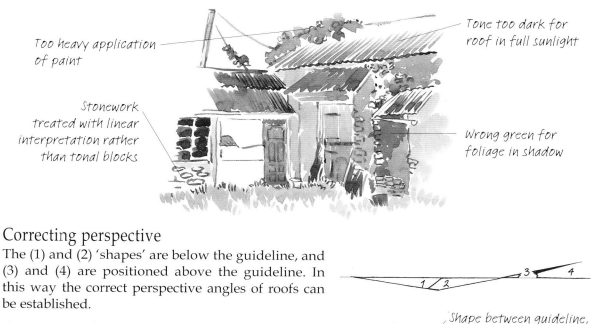

Too heavy application of paint

Stonework treated with linear interpretation rather than tonal blocks

Tone too dark for roof in full sunlight

Wrong green for foliage in shadow

Correcting perspective

The (1) and (2) 'shapes' are below the guideline, and (3) and (4) are positioned above the guideline. In this way the correct perspective angles of roofs can be established.

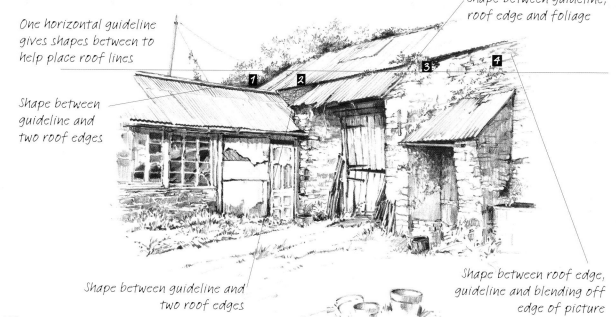

One horizontal guideline gives shapes between to help place roof lines

Shape between guideline and two roof edges

Shape between guideline, roof edge and foliage

Shape between guideline and two roof edges

Shape between roof edge, guideline and blending off edge of picture

Solutions

Tackling textures

This study required many brush angles and pressures to achieve the effects of a variety of textured surfaces. It shows the various stages of underpainting used, and also how the subsequent washes were built up gradually until the right colour and depth were achieved.

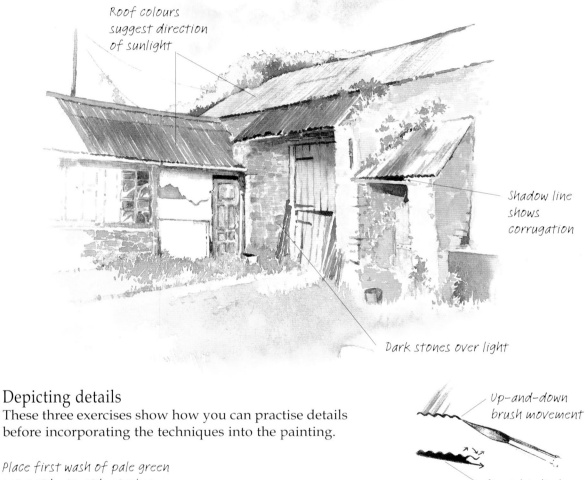

Roof colours suggest direction of sunlight

Shadow line shows corrugation

Dark stones over light

Depicting details

These three exercises show how you can practise details before incorporating the techniques into the painting.

Up-and-down brush movement

Straight shadow line beneath

Place first wash of pale green using side-to-side strokes

Pull brush strokes down over dry surface, using darker green mixed with plenty of water

Dark stones over light

Side-to-side brush movements

Light stones with dark recesses

Pull down and across

Street Scenes: Typical Problems

A variety of buildings within a street setting will be viewed at different angles. Perspective problems may be overcome using the 'guidelines' method – aligning parts of one building with another. Any awareness of scale can be helped by the inclusion of a figure, but this needs to be treated with care. It is far better to draw/paint a figure slightly too small than too large – as seen in the painting below, which also shows how a too heavy-handed treatment of background areas can overpower the foreground.

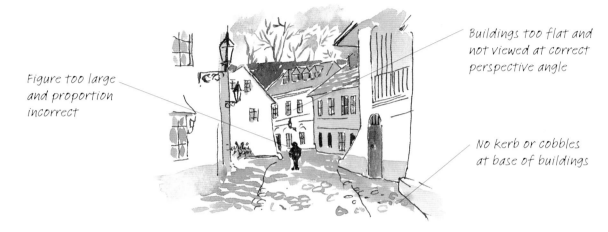

Figure too large and proportion incorrect

Buildings too flat and not viewed at correct perspective angle

No kerb or cobbles at base of buildings

Quick sketchbook impression

Here, a fine-nibbed pen was drawn over the surface of textured paper to establish a wide view of the scene, before moving in close to the centre of interest.

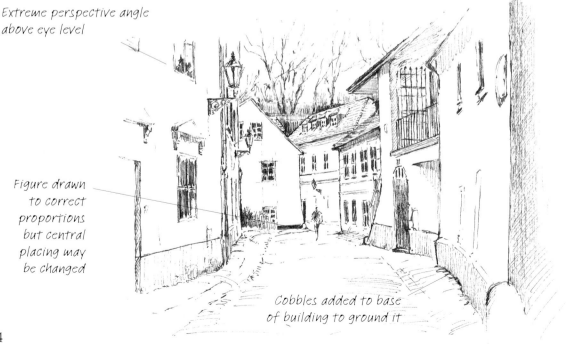

Extreme perspective angle above eye level

Figure drawn to correct proportions but central placing may be changed

Cobbles added to base of building to ground it

Solutions

Drawing and tinting

For this exercise, draw the entire scene in pen and ink on textured watercolour paper, using a thick-nibbed pen for the wider lines.

Vary the pressure on the pen to encourage it to create interesting lines, then work with the texture of the paper to enhance these effects.

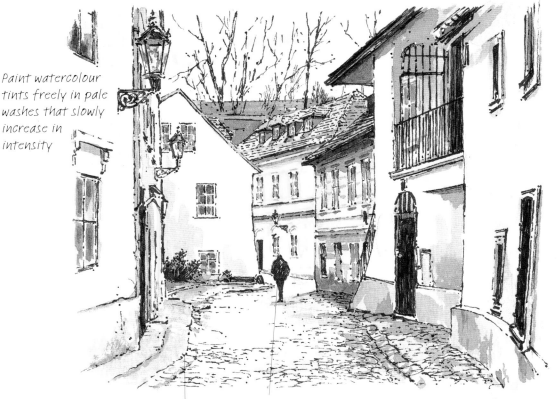

Paint watercolour tints freely in pale washes that slowly increase in intensity

Lines along kerb guide eye into picture

Figure slightly off-centre because we now see less of left-hand wall than in sketch

Drawing with a pen

Here are four exercises to use as a warm-up as you practise penwork prior to starting the final drawing.

Vary pressure on lines that differentiate buildings

Squiggles and lines of varied pressure plus tonal blocks give effect of quick impression

Avoid drawing wirelike line around each cobblestone – lift off and then re-apply pressure

Draw right angle first, then curves and pattern shapes

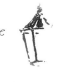

Arrows show side-to-side movement to depict cobbles seen in perspective

Glass-Fronted Buildings: Typical Problems

Glass-fronted buildings that reflect their surroundings produce images reminiscent of surrealist paintings. As an artist you may feel that the interest lies not in the overall shape of the building, but in the reflected images distorted by slight undulations of flat glass panels – but the maze of vertical, horizontal and distorted lines are difficult for a beginner to view, let alone draw and paint with accuracy.

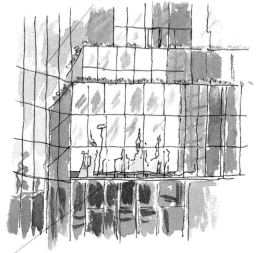

Bars painted carelessly and too heavily, as well as at wrong angle

Drawing distortion

Close observation of the scale and perspective in the scene are the primary considerations. Once these are noted you can consider how they have been altered through distortion. Here, there is a helpful grid of vertical and horizontal bars, so that you can concentrate on one section at a time.

Loose `squiggles' with same colour in each one do not give impression of range of buildings

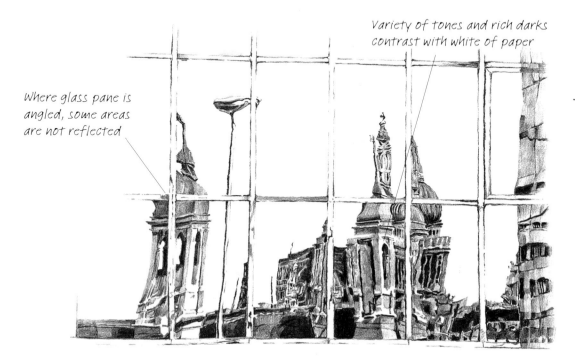

Variety of tones and rich darks contrast with white of paper

Where glass pane is angled, some areas are not reflected

Solutions

Quick impression

The quick sketchbook impression to the right establishes the building as a whole before selecting an area for detailed interpretation. Drawing on-site, where you can establish basic proportions and perspective angles, can be regarded as a warm-up exercise. There is no need to draw precise details if it is your preliminary interpretation prior to a more detailed drawing and painting of a small area.

Building a mirrored image

Place the grid and consider the content of each section in its own right, as well as regarding the picture as a whole. Show some of the external glass side-panelled wall of the building in order to retain identity, and then start by painting everything as an undercoat of pale washes.

Retain identity of building by portraying part of one side

Paint reflects blue sky to enhance white (paper) images of glazing bars

Undercoat of pale washes

Enrich dark areas in final washes

Note undulations of reflected shadow lines

Index